# PAINTING

# CAN

# SAVE

# YOUR

# LIFE

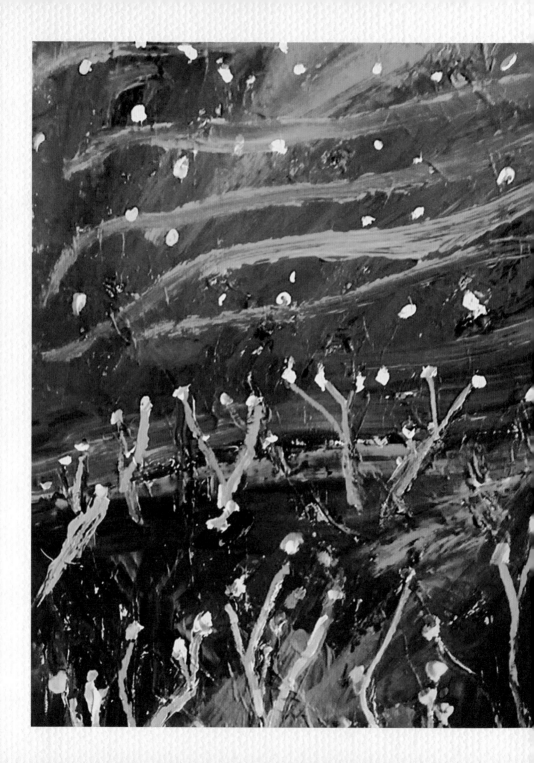

# Painting Can Save Your Life

## HOW & WHY WE PAINT

### Sara Woster

A TARCHERPERIGEE BOOK

an imprint of Penguin Random House LLC
penguinrandomhouse.com

Most TarcherPerigee books are available at special quantity discounts for bulk purchase
for sales promotions, premiums, fund-raising, and educational needs. Special books or
book excerpts also can be created to fit specific needs. For details, write SpecialMarkets@
penguinrandomhouse.com.

ISBN (hardcover) 9780593329948
ISBN (ebook) 9780593329955

Printed in China

10 9 8 7 6 5 4 3 2 1

Book design by Lorie Pagnozzi

*To R.,* FOR SHARING YOUR MOONLIGHT

# Contents

PAINTING

CAN

SAVE

YOUR

LIFE

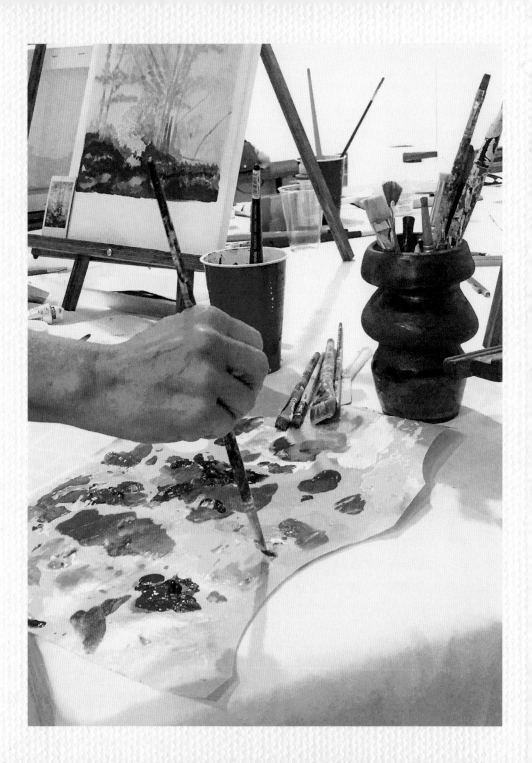

## INTRODUCTION

**M**y journey from painter to painting teacher began because my daughter is a solid first baser. Her flexible, long limbs, a rabid competitive streak, and her unflappable nature allow her to catch most balls that come her way and remain unphased by opponents racing across first. As a result, much of our social life in the spring revolves around her games and the families of the other players.

After one game we went for pizza at the house of Jake and Jodi, a good-looking, high-energy couple with a passion for saving the planet and a daughter who pitches on the Brooklyn Bombers. It was my first visit to their house, and I noticed many beautiful paintings, all uniform in size and using a palette that reminded me of Thomas Eakins's oceanscapes, lining the dining room on a picture shelf.

"Who painted these?" I asked them.

"My father-in-law painted them," Jodi told me. "He had never painted in his life before he wound up in an assisted-living facility that had an arts program. He loved it. It's a shame that he didn't discover it earlier."

You don't make paintings that beautiful without having been born to paint. The fact that he only discovered his talent at the end of his life kind of broke my heart.

And the larger impact of an absence of arts opportunities is something I started thinking about a lot. Kids obviously need to make art, but so do isolated seniors and new mothers suddenly at home. Men and women working jobs they hate who return home to spend the night trying to find a way to feel better should be making art as well. Recently retired men and women who are looking for a new focus for their sudden excess of time and people who are neurodiverse or dealing with mental health issues should be making art, too. Even Jake's father, who had a wonderful family and a purposeful life without painting, might have made new and different friends or found a stress relief tool if he'd found painting earlier.

Without any real idea of what I would do with it, I began plotting a simple painting method with a steep success curve so that people who might fall in love with painting would uncover that fact quickly, before frustration set in and they gave up.

I had to figure out how to make the exercises meaningful to each individual painter; for people to stay interested, they would have to make paintings that mattered to them from the onset. People don't want to slog through repetitive exercises or copy other people's paintings, having the colors and compositions dictated to them, which is the method some how-to painting books and methods employ.

My goal was to create an easily accessible portal to painting. A method to get somebody started and give them enough confidence so that they could then continue with in-person classes at a local arts center or com-

munity college, seek out other books that explore specific types of painting, or find a local painting group. I would not attempt to re-create the college-level experience some of my friends give their lucky college students; instead, I wanted to instill a love of painting and a confidence in basic painting skills in people who don't have the time or the money to dedicate themselves full-time to learning to paint.

But once I had a firm layout of the method, I was terrified of saying that I wanted to actually use it to teach anybody. Who was I to teach anybody anything? Yes, I had twenty-five years of dedicated painting behind me, and as many years of obsessively looking at art, but I had no teaching degree, no MFA. I was scared to say publically that I thought I knew enough about this very hard thing to pass it on to others.

Luckily, my belief in my ability to teach people how to paint was stronger than my fear of people making fun of my desire to teach painting. One day I hit send on an email announcing the first class of my tiny painting school, named The Painting School, and just like that I became a painting teacher.

The adult classes were held in an upstairs gallery space above a coffee shop. I arrived with small tabletop easels, canvases, and whatever we needed to do each exercise, whether that be toy dinosaurs or Styrofoam cones. Somebody always brought wine.

I had been surprised by how many of the people who responded to my initial class offering were friends of mine who had never expressed any interest in learning how to paint. I was less surprised that only women signed up—most of whom had big jobs. I was honored that these women arrived to paint after an intense day of work preceded and followed by childcare.

During that first class, everybody seemed both excited and a little nervous. I told them all to pick an easel and get out the paints they had purchased in advance. I laid out a pile of fruit and objects like a baseball, a high-heeled shoe, and toy cars. We set out to learn how to paint those objects' silhouettes—the same exercises we do in Chapter Three of this book.

All of my painting classes, whether for kids or adults, are designed to be fun, even while we are learning the foundational elements like color mixing, composition, and the ratios of the human body. For a class on painting animals, we built a ridiculous still life full of stuffed animals, ceramic dogs, and a taxidermy squirrel. For the observation class, I brought in piles of flowers and let the artists build their own bouquets to paint.

My classes for kids are even more fun. For a class on painting an outer space scene, I blasted the music from *Star Wars* as the students filled their painted skies with celestial shapes never before seen by astronomers. For a class inspired by Wayne Thiebaud, I brought in a massive variety of mini cakes, which we ate after painting them. For color mixing, I brought in a hundred different house paint swatches from a hardware store and split the kids into teams. They collectively tried to mix and match as many of the swatches as possible in a half-hour period.

I treat all of my students, whether adults or children, not as dabblers, but as artists. At the end of the six-week class period, I brought in an artist to do a critique of their work, the kind they might have endured in art school. I took my class to museum shows to look at paintings with the new lens that learning to paint had given them. The impact of the classes on the new painters' ability to look at art can't be overstated. When they looked at a show of Grant Wood paintings at the Whitney

Museum of American Art, they no longer saw a bunch of beautiful paintings; they saw the perspective tricks, warm and cool color choices, and symbolism that came together to make each painting.

What I hadn't expected was how quickly new friendships would develop from the class. Some of my friends knew each other a little, and some had never met because they were from different areas of my life. But soon people were forming new friendships and connecting outside of class, bound together by their newfound love of painting. And maybe, in this terribly lonely world—a world so lonely that Japan just created a Minister of Loneliness cabinet position—the most important thing learning to paint does is build community. All art brings other artists into your life—just look at the communities that build up around cosplay or gospel choirs or quilting bees or photography clubs. And those artist friends are important. They are the people who will remind you of all the reasons that the world is better with you here because they are the people sensitive enough to notice when you need a reminder.

Art can be transformative in so many ways like that. Painting offers the potential to outpace your own expectations of yourself, to try to perfect something. It is a way to be mindful without having to do the dreadful downward dog. And in learning to paint, you might end up simply doing the powerful act of making something beautiful that you can gift to someone else.

Making art and looking at art can improve the world by improving us. The artwork I truly love increases my empathy. Great art emits such a strong light that it helps us see the world with more clarity, something like what Henri Matisse called "illuminating the fog that surrounds us."

If nothing else, your own world will be illuminated through painting. After reading this book, you will notice things you didn't notice before. After the chapter about the color wheel teaches you that red and green are complementary colors that vibrate when located next to each other, you never again will ignore the red rose next to its green stem. The light and shadow chapter, where you learn that different light sources create different types of shadows, will have you noticing the starkness of the shadow that your bedside lamp casts under a mug of tea. Doing the exercises on painting the human figure will have you observing the slouch of every man on the subway, the posture of every young girl walking into a ballet school. The chapter where we paint our interiors will make you reconsider the objects in your room and the moments that you live in those rooms in a new, poetic way. Learning how to paint a flower by observing its stem's specific bend will train you to notice the nuances in the natural world. The chapter on symbolism will force you to think about what matters to you and what objects best symbolize those important things.

Yes, in this book you will learn how to do important technical things like mix paint and map out the correct proportions of a human face, but I hope it teaches you more than that. I hope it helps you learn to live like an artist by becoming hyper aware of the world and your role in it. The writer Zadie Smith has said that she writes so as not to sleepwalk through her life.

Or maybe you should paint because you are a sad person trying to thrive in a world that makes it clear, in so many ways, how much it kind of despises sad people. Painting saves me all the time by transforming my bad emotions into something less bad.

Georges Braque more eloquently said, "Art is a wound turned into light."

I titled this book *Painting Can Save Your Life* in reference to all these important ways that painting can help save a person from loneliness and apathy and the impact of all the stresses we face each day. And I called it that because art can save you by making it easier to do the brave, difficult work of staying hopeful and engaged with the world throughout, as Mary Oliver said, our "one wild and precious life."

*chapter one*

## THE ART STORE

When I was growing up in Sioux Falls, South Dakota, in the 1980s, people were optimistic and tough. They valued stoicism and fiscal restraint, and the hard streak of libertarianism running through the state meant that you didn't have to wear a seat belt and nobody cared what went on in your bedroom. The local government supported the arts and made sure that the Parks and Rec department was well funded. It was a great place to live if you didn't mind the humidity. And except for that humidity, there was no complaining because it was the belief of most South Dakotans that unless your whining was coming from an iron lung, you had nothing to complain about.

I had even less to complain about than most. I lived in the world's greatest neighborhood on South Sixth Avenue with a pack of free-range kids to bike with every day and play kick the can with every night. Most

of us lived in small, one-story houses. Nobody on our block had any extra money, but the houses and yards were well tended.

My parents were good at parenting and not into spanking. My father is charming, gentle, and musical, with a hot temper that emerges in the car. A local celebrity, he gave the cattle reports on KELO-Land television and hosted any number of pie contests, FFA banquets, and, starting when I was thirteen, his own weekly variety show. My mom, a former high school teacher turned librarian, is cerebral, unflappable, and tireless. She came up with fun projects for us to do on hot summer days and cooked amazing meals, which we ate promptly at 5:30 every night. I was the only person who did not think that my sister was perfect; her tendency to physically assault me if I wore a pair of her jeans prevented me from sharing that citywide opinion. My brother was not interested in me enough to bother me; he was too busy hiding in his basement bedroom listening to Steve Martin and Richard Pryor albums, writing short stories for horror magazines, and practicing big band songs on his sax.

Our house was just large enough for everybody to have their own small bedroom, and in our backyard, a chain-link fence held a cockapoo, a weeping willow, and a vegetable garden. There was no need for a security system; my dad left his car keys in the ignition of his car at night. I didn't know danger unless it was coming from a weather pattern.

But even if we did have problems, it isn't like we would talk about them. As my father likes to say, "Don't tell people your problems. Fifty percent don't care, twenty percent do, and the rest are glad it's happening to you."

So what do you do in that world of no complaints and glaring opti-

mism when your range of emotions veered to the left as everybody else veered right? When you were labeled "moody" from an early age, struggled to leave your mother's side, and had panic attacks when getting your hair washed at the hairdresser. The kind of kid who, on the first day of kindergarten, when your mother told you not to touch the hot burner that just held her coffee pot, you pressed your soft, five-year-old palm onto the red-hot coils. And when you were rushed into basements during tornado warnings and the rest of your family calmly played Sorry and Clue and waited for the weather to pass, you hid beneath a pile of wheat-smelling stuffed animals and waited to die. What do you do when you have both insomnia and a bottle of Mylanta in the seventh grade?

For a while, I dealt with my dialed-up emotions and overactive senses by suspending myself in my imagination and books. I had imaginary friends long beyond the time that it is acceptable to interact with invisible people. I was the last to give up on Barbies. I made little friends out of pom-poms and brought them to Catechism class, where I set them on the edge of my desk and Amy McCarthy turned around to ask, "What the hell are those?"

I didn't want to be viewed as the weirdo that I was pretty sure I was, so I learned the boundaries that contain normal people and stayed within them. I tried to pretend that the way the world made me feel wasn't the way the world made me feel. Then one day I discovered the two short shelves of art supplies at B. Dalton bookstore in the Sioux Empire Mall and somehow convinced my mom, a woman renowned for her ability to shut down any request at any store, to buy me a metal case full of drawing pencils. I brought home those pencils, began copying images

from *National Geographic*, and discovered that art could serve as a tiny valve capable of releasing just enough of my unwarranted angst and tightly wound personality to make breathing, sleeping, and interacting with other humans a bit easier.

**MOST OF MY PAINTBRUSHES HAVE BEEN AROUND FOR YEARS.** Many are shredded, splayed, akimbo, and nothing any respectable painter would admit using. The bristles are bent and dislocated, and the marks they make are messy. My more expensive brushes maintain some shape, even after years of my abuse. The handles of the brushes are coated in technicolor crusts of acrylic paint. The bristles on the cheapest brushes have all but disintegrated, but I keep them all; they fit so perfectly in my hand. And the marks, blobs, and strokes that emerge from them could

wind up being exactly what I need sometime down the road for the curve of a vase, the tail of a horse, or the wave of an ocean.

Painters are trained on the future like that. It is one of our primary tasks. What could emerge from this little bit of pigment mixed with a tiny bit of water? There is so much abracadabra and alchemy in making a work of art. We are believers in potential.

After thirty years of painting, I'm not always conscious of my selection of brushes. I rarely actively walk myself through color choices; at this point, the art supplies are an extension of myself and I no more consciously think about what brush I should use than I consciously urge my lungs to suck air in and propel it back out. I reach for my brushes, feel around for the right size, select one that is about the correct width, and smash it into the side of the old yogurt container that holds my water to force out the excess water. I test the give and bend of the bristles. If the give and bend doesn't feel right, I replace that brush and try another. Depending on how wet I want my mark to be, I might blot the brush onto a paper towel to get rid of excess water.

I look at the canvas and decide what part of it needs work. I squirt out some paint, maybe a pink the color of lacy underwear or a mausoleum-like gray or a bright, yellow-green like a patch of sun-drenched lily pads. I drag my brush through the paint before turning to the canvas and making my mark in the place that my gut and my eyes and my brain have conspired to urge me to put it. Most of the time it is just one of a hundred marks I will make on that canvas, but eventually one mark will cause my gut and my eyes and my brain to agree that it is time to tell my hand to put down the brush: "That's it! That's the final mark."

PAINTING CAN SAVE YOUR LIFE

*{16}*

I DIDN'T ALWAYS USE MY MATERIALS WITH SUCH CERTAINTY.
I started where every beginner painter starts, with no idea what to use or when to use it, what to buy or why I need to buy it.

Art stores can intimidate the new painter, and back when I first started painting, they were even more intimidating. Not so long ago, art stores were manned by actual artists, art students, and all types of delightfully pretentious people. The staff would sneer at you or ignore you when you entered the store or, even worse, corner you and go on ad nauseum about the benefits of a specific brush. Like record stores and sex shops and comic book stores, art stores were where fanatics had day jobs. Those independent stores manned by zealots also did the heavy lifting of community building and knowledge sharing, things that have since migrated online.

Some of those wonderful independent art stores still survive, but I'm sure many more art supply purchases now happen at chain stores and online. For the new painter who lives in a rural area or has trouble getting around or just prefers the convenience of home delivery, the option of ordering supplies from Dick Blick is wonderful. And I have no problem with making paint another item on your list of things to pick up at the mall. But be warned: the knowledge gap between a practicing, extremist, art-obsessed independent clerk and most Michaels cashiers is a wide one. That gap might not impact you in the early stages of painting, but later, seek out the experts working at your independent art store. The knowledge they can share with you will raise the level of your artwork.

The first real art store I ever shopped in was on the West Bank of the University of Minnesota, and I was intimidated by every aspect of it—its size, the scope of its offerings, the punk staff. Located in a massive space that had been used for manufacturing, the store held paint,

markers, canvases, pastels, brushes, and pigments, filling the walls in lines of color, like layers of sedimentary rock. I didn't know where to find anything, but I was too scared to ask for help.

Later, when I worked as a receptionist at the Minneapolis College of Art and Design, I bought my art supplies at the cramped store there. When I won a $7,000 art grant—one-third of my yearly salary at the time—I asked the store manager to order me several thousands of dollars' worth of paints and canvas. When I picked up the supplies, I remember it as a store-wide celebration; the staff understood what a big deal it was for somebody like me to paint with only ambition and stamina limiting my creative output, not finances.

Money is always the problem for painters because paint is expensive. It is daunting to figure out how to buy what you need with what you have. In my case, in order to buy paints and also feed my children, I work a full-time job and my husband and I make financial decisions based on our art. I might pay $400 for paint but won't get a new phone until my old one is nothing more than a shattered screen and duct tape. We pay rent on my husband's studio instead of going to Disney World. Rob has expensive tools, but we bought our car from a grumpy dad in New Jersey for $3,000. We value making art more than we do other things and pay for it by not doing the things we value less.

This is a privileged position to be in. Most people don't have the luxury of swapping out anything for painting supplies because they just have enough money for food, shelter, and gas. But for the premise of this book, I have to assume that you can afford the bare minimum of art supplies and will walk you through the process of buying what you need to do the exercises in it.

## Visiting an Art Store

If the idea of finding what you need in an art store intimidates you, I don't blame you. That's how I feel when my husband sends me to AutoZone with a line drawing of a spark plug. I feel stupid that I don't belong and that I am annoying the clerks with my questions.

But we can lower that intimidation factor by preparing you for what to expect at an art store.

### What Do You Need to Paint?

You only need five things to make an acrylic painting: water, paint, something to mix your paints on, something to paint with, and something to paint on.

### *Paint*

The paint section of an art store is massive, and the print on the paint tubes is tiny. Paint is available in three types: oil, watercolor, and acrylic. We will be using acrylic paint because it is easier to learn how to mix colors with acrylic; it dries quickly; and you mix acrylic paint with water, not toxic solvents.

When you locate the acrylic paint, you will notice a variety of sizes of tubs and jars. For our initial mixing purposes, you should be fine buying most of your colors in the smallest size tube, 2 ounces. If you can afford the 5-ounce tubes, go for it. That allows you extra paint to play with. Paint is also sold in 8-, 16-, and 32-ounce jars. I always buy the paint I use more frequently, like white and black, in larger sizes.

## Student Versus Professional or Artist

Most paint companies offer two levels of paint quality in two different price ranges: professional or artist level and the less expensive student grade. Student grade is a solid, more affordable option to use when you are getting started, but the pigments in the student versions are less pure, so learning to mix paints with them can be frustrating. If you have the money, I suggest that you start with a professional or artist grade while learning to mix. But if student grade paint is what you can afford, it will be just fine.

## Series 1–8

There is a series number somewhere on the tube. The lower the number, the cheaper the paint. The number reflects how much each color costs to produce, not the quality of the paint. So a series 8 blue is not necessarily a better blue than a series 3 one.

The series number is often the biggest criteria of how I select a color. If a naphthol yellow is series 2 and a cadmium yellow is series 7 and I'm kind of broke, I'll pick the naphthol and make it work. Or if I know I want to paint a huge portion of my canvas blue, I might consider painting that portion a series 1 blue in order to save some money.

The price of paint is based on that series number, and a sign in the painting section usually lists what a 2-ounce series 4 paint costs, a 5-ounce series 8, etc.

## Permanence/Lightfastness

You will see another number on the tube about the paint's lightfastness, which is how well a paint retains its color over time. The range is usually 1 to 3. A 1 means the color will last more than 100 years, a 3 means it will last between 15 and 50 years.

## *What Paint Colors Do I Need?*

*Acrylic Paint Sets*

The easiest way to get your initial supply of paints is to purchase an acrylic set designed for beginners. Golden Artist Colors has a few wonderful acrylic beginning color theory sets for around $50. If you wait for a sale or discount code at one of the national chains, you can probably knock that cost down to $40. Winsor & Newton has a Professional Acrylic starter set of 12 colors that is $39 as I write this. Dick Blick has a starter set of 12 colors for $37. The best sets have two yellow options, two reds, and two blues. You should also buy a black and a more natural shade like a raw sienna or burnt sienna if that is not in your set.

Or you can purchase individual colors.

## Bare Minimum Paint Colors

It would be ideal for you to buy two reds, two blues, and two yellows. But if you can only afford one variety of yellow, red, blue, white, and black and one earth tone like burnt sienna, you can still do the lessons.

Here are some good choices:

**Red:** Naphthol red light or cadmium red light and quinacridone red

**Blue:** Ultramarine blue and phthalo blue (green shade) or manganese blue

**Yellow:** Hansa yellow light or cadmium yellow light and diarylide yellow or hansa yellow medium

**Earth color:** Burnt umber and/or burnt sienna

**White:** Titanium white

**Black:** Mars black

## The Super Power Colors

These are some of the most versatile colors I turn to repeatedly because they mix well with different hues, whites, grays, and black:

**Ultramarine blue:** Ultramarine makes a rich green. When you mix it with crimson, you can make a great violet. Renaissance painters mixed it with brown and white to create rich grays and a variety of skin tones.

**Phthalo blue (green shade):** This greenish blue is cool and bright. Adding a bit of it to yellow creates a dynamic green.

**Cobalt blue:** I use this cooler blue anytime I want to paint a sky that goes far into the distance. And if you mix it with white, it creates a cool, olden days gray.

**Cerulean and manganese blue:** Bold options I often use for skies.

**Cadmium red light:** This brilliant red is great on its own or with white to make a strong pink. It won't make a good purple.

**Naphthol red:** A solid, more affordable red that mixes well.

**Alizarin crimson:** This strong red makes a lovely pink when mixed with white. Mixing it with phthalo green creates a moody, dark sky that Tim Burton might use on a movie set. It also mixes a nice violet and orange. It's my go-to color when I'm "in a mood."

**Burnt umber:** A great tone for earth, hair, and dogs.

**Raw sienna:** My favorite earth tone.

**Raw umber:** This yellowish earth tone is great for landscapes and is better mixed than on its own.

**Red oxide:** This hot earth tone mixes well and is just what you need to paint a Vermont fall landscape or your grandma's 1970s flowered living room furniture.

**Yellow ochre:** Mixes well to create a wide range of skin tones. A bit of red or blue makes a nice olive skin tone.

**Cadmium yellow:** Hot and bold—use it for your suns!

**Hansa yellow:** A little cooler, less like what we see in nature. Use this when you want a muted light.

**Quinacridone red:** One of my all-time favorites, I constantly blend this with white to create my favorite, most-overused pink.

**Mars black:** I slightly prefer Mars black over ivory black because it feels warmer, darker, and denser to me. I like the grays that it mixes.

**Ivory black:** More brown black, a great general black.

**Payne's gray:** A wonderful dark color with a cool purple undertone that makes it great for a shadow.

**Oranges, greens, and purples:** These secondary colors are created by mixing the primary colors. Aside from the phthalo green that I listed, as we learn to mix, I suggest holding off on buying these premixed secondary colors because the goal is to learn to mix these colors yourself. But eventually, there are wonderful oranges, greens, and purples to play around with.

## Additional Favorites

One year my husband bought me a bunch of paint for Christmas. It was a thoughtful gift, but he selected colors I never would have picked, and it took me a while to figure out how to use some of them. Painters are creatures of habit when purchasing paint, and eventually you will find yourself grabbing the same colors over and over, too.

Here are some of my favorites:

**Prussian blue:** Alone it looks like the color of a Russian czar's robe; with white it becomes a brilliant, light blue.

**Alizarin crimson + turquoise:** This combination creates complicated night colors, and I'm usually feeling pretty complicated when I have the urge to paint.

**Light magenta:** A great pink that I often treat as a neutral, like gray or taupe.

**Neutral gray:** A great way to temper the many overly bright colors I like to use.

## The Reckless Extras

If you have money left over, grab a tube or two of something more expensive and intense, like a color you might see in a dream or while doing psychedelic mushrooms. My reckless, wild card pick is always fluorescent pink.

## What to Paint On

The paper and canvas section of an art store offers a variety of painting surfaces: paper, wood panels, and canvases. As you progress it will be fun to experiment with boards, canvases of different shapes and colors, and different types of paper. To start we will use paper and canvas.

Anytime you use regular paper that is not canvas paper, you first need to paint it with gesso, a white paint that prevents your acrylic paint from seeping into the paper. You can find gesso in the paint section. Or, better yet, look for something called canvas paper; oil and acrylic pads; or Canva-Paper, thick paper treated with a layer of gesso.

As we move into making landscapes and portraits, if you have space in your home for canvases, your local art store and chains like Michaels sell prestretched, pregessoed canvases for relatively cheap if you buy in bulk. They come with the added bonus that if you like your painting, you can put a thumbtack in the wall and hang it up.

## *What to Paint With*

You'll likely start painting with brushes. In the brushes section of the art store, look for the brushes labeled acrylic or acrylic and oil. *Do not buy watercolor brushes.* I recommend buying a brush set when you first start, one that includes a square brush, a round brush, and a small brush for detailed painting. You are looking for a diversity of size. Don't spend a ton of money on these. Once you figure out what type of marks you like to make, you can invest in those types of brushes. I recommend also buying a 1- or ½-inch-wide brush for covering larger surfaces if that isn't included in your set.

Here are a few popular brushes and the kind of marks they make:

**Flat:** A square stroke, great for applying solid marks with a lot of paint and filling in big areas. Or turn it to the side and make lovely thin marks.

**Bright:** Like a flat but shorter, stiffer, and stronger, it is round in the middle so it makes nice organic shapes.

**Filbert:** This brush makes a more elegant, energetic mark—think ocean waves or tendrils of hair. It provides a wide variety of marks so is a great all-around brush.

**Round:** Great for making lines, filling in narrow spaces, or making dots. I use smaller round brushes for details. It's good for when you need to be in control.

**Angled:** Makes great thin lines and curves.

## *Additional Painting Tools*

Here are a few additional, and inexpensive, art supplies that will enhance your painting experience.

**A color wheel:** Most art stores sell small, plastic color wheels. If your store doesn't have one, you will have to order a wheel online because it is an essential part of this painting program. You can order them from any art store. The pocket size one from The Color Wheel Company is perfect for our purposes.

**Palette:** You need something to mix your paints on, like an inexpensive plastic palette or a pad of palette paper.

**Palette knife:** One do-it-all painting tool that is worth buying is the palette knife. These plastic or metal palette knives are great for blending your paints well. Some painters use palette knives for applying thick swatches of paint.

**Tackle box:** Many painters keep their supplies in tackle boxes so their brushes don't get crushed, the paint doesn't get all over everything, and you can easily transport or put away your supplies when not using them. Of course, you can also use a cardboard or plastic box.

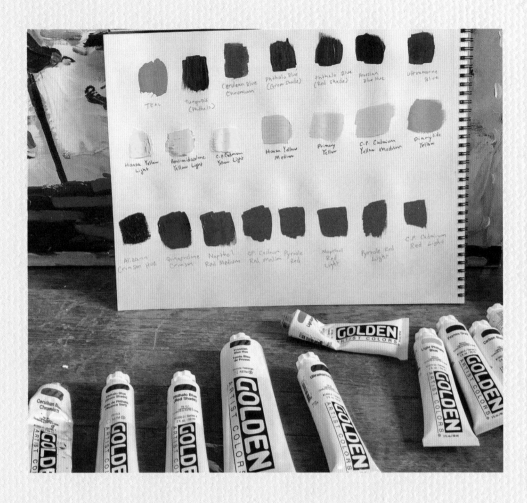

*chapter two*

## COLOR WHEEL/MIXING PAINTS

The first job I ever had was selling shoes at a department store in the mall when I was sixteen. Since then I've had countless other jobs. I hand-painted swirls and hearts onto T-shirts designed for ladies who love to golf, handed out free samples of orange juice on a ski slope, and was a hostess at a faux Tex-Mex restaurant. And in my late twenties, I worked at ad agencies in New York, producing photo shoots for advertising campaigns.

For one project, I traveled with the agency's creative director, the photographer, and his crew to a five-day shoot to take photos for the marketing materials of a private jet company. On the first day we scouted locations for potential shots. Our tour guide was a beautiful older blonde with a Southern accent and a face full of Mary Kay. A silk scarf was tied around her neck, and a crucifix was pinned to her lapel. She stood erect. She was sassy.

She brought us to a fleet of private jets full of soft leather and fingerprint-free chrome. We met the mechanics who worked in a spotless air hangar, the photogenic pilots, and the even-keeled women of customer service whose job it was, among other things, to ensure that the dogs of the rich and famous customers had their favorite brand of dog food onboard. It was bizarrely clean and happy, the kind of place that would be born if Disney started manufacturing small aircraft.

At the end of the tour, our guide brought us into a massive warehouse that held three flight simulators, white and shiny pods suspended on massive hydraulic jacks. Each of us was allowed to attempt a landing into LaGuardia Airport during a thunderstorm. The simulator was so good that it felt like I actually was landing a plane in a rainstorm on an impossibly narrow strip of land. We were giggling and full of adrenaline as we climbed back down.

Our guide explained that even pilots with thousands of trips under their belt relied on the simulators to practice flying their planes in any number of worst-case scenarios.

"That was terrifying," the photographer said. "It felt like I was really landing a plane."

"It should feel real. It costs a half million dollars to make each one of those simulators," our guide said. "After all, it takes many scientists and engineers and machinists a lot of money to make it feel like you're flying. Only God can make things actually fly, and he can do it for free."

This is how I feel about mixing realistic colors.

You can spend your entire life attempting to re-create some color you see in nature, but you will never win. God will keep that color elusive. Or Mother Nature. Or science or optics or whatever you give credit for

the red flash of a cardinal's wing. Mixing paint colors is really nothing more than the fruitless attempt to re-create natural things using artificial pigments and the artificial substances that carry them.

But we are still going to try.

WE HAVE A LOT OF BEARS LIVING NEAR OUR HOUSE IN THE CATSKILLS OF NEW YORK, INCLUDING A MOM AND HER TWO CUBS, WHO FREQUENTLY LUMBER THROUGH OUR YARD WITH AN AIR OF ENTITLEMENT. And while I wish they would take my house off their circuit, especially given all the reality content my husband forces me to watch that involves men in Alaska warning camera crews of the volatility of mama bears with their cubs, it is exhilarating to see something wild close up. The black color of their fur is so rich and all-encompassing that the bears seem to be nothing more than bear-shaped black holes swallowing up their surroundings.

An artist named Anish Kapoor recently bought the exclusive rights to paint with something called Vantablack, supposedly the world's blackest black. It is a color getting unsettlingly close to singularity black, the bone-chilling black at the center of a black hole. Vantablack is all well and good, but the black of a bear's hide? There's still no manmade version of that.

Capturing a color we see in nature is an amazing feat. Flesh tones have tormented painters for hundreds of years, as has the impossible-to-capture color of the iris of a human eye and the violet blue of the gloaming hour sky. And what exactly is that light turquoise that is also a kind

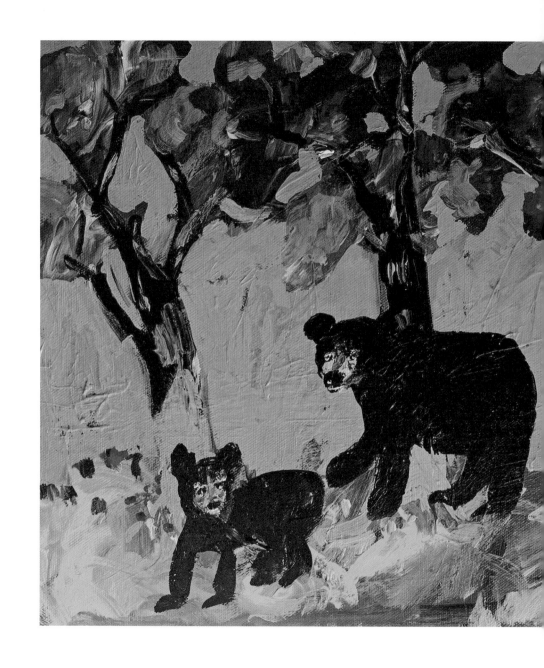

PAINTING CAN SAVE YOUR LIFE

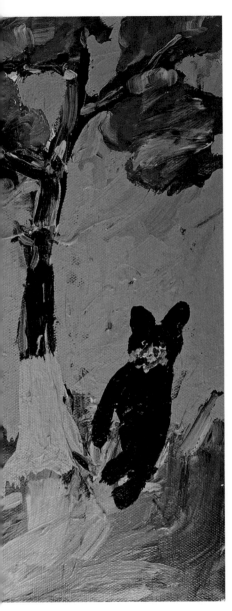

of silverish gray that rides the crest of a wave in a turbulent, moonlit ocean storm?

Manufactured colors don't get close to providing us what is required to re-create a bear's inklike fur, or the silvery green underbelly of a cottonwood leaf, the vibrant flesh of a blood orange, or the brilliant green of poison ivy leaves. You could purchase every color made but, just as flight simulators only offer a facsimile of flight, you would still only produce facsimiles of those amazing natural colors.

Painters, hopeless optimists that we are, keep trying to mix those colors anyway.

Why does it matter if you know how to mix colors well? Let's say you want to paint the oak tree in the backyard of your childhood home. The color you create matters because if you capture that tree in just the right way, it might symbolize a time when you felt happy and loved, or how it feels to be alone and scared, and suddenly you have made a painting that exposes something about you to the world.

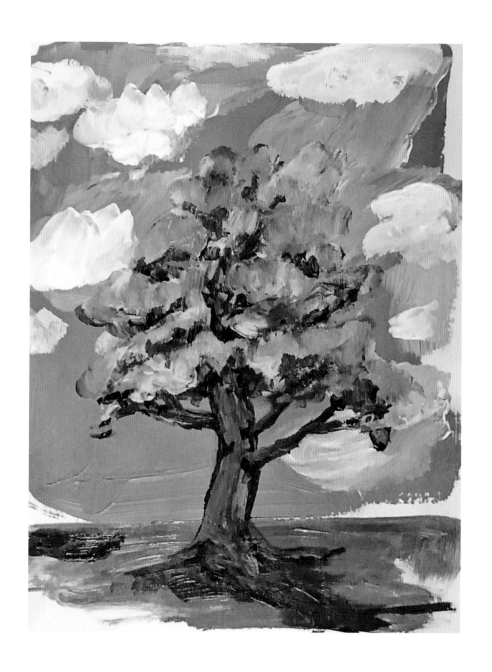

PAINTING CAN SAVE YOUR LIFE

Painting the green leaves on a tree doesn't have to just be about the tree; it can be about a story connected to the tree. It isn't always just about the black color of the bear; it can be the story connected to the bear. Painting a bear that is prowling around the grounds of a new house, where renovation is endless and we've run out of money and a pandemic has trapped my family inside the house that the bears circle, *and* I'm worried that we have done something wrong with our compost pile to draw these bears and bother our new neighbors . . . that is an interesting story to paint. We aren't just mixing paint in order to paint trees and bears; on our best days, we are capturing some version of the bears and trees to tell everybody how we relate to the world that those bears and trees populate.

Even if you want to create abstract paintings and not mix an exact replica of something found in nature, you still need to mix colors well to ensure the colors in your paintings have strong relationships with one another. Whether you are painting a landscape or a color field painting, your goal is a dynamic color combination that passes through your viewer's eyes and hits their solar plexus with a bang.

We have had some brilliant colorists over the years, painters like Rembrandt and Titian, Manet and Sargent, who captured the spectrum of color found in the indentation in a crystal wineglass or the light reflecting off crisp, pale-colored silk. The contemporary British painter Lynette Yiadom-Boakye is a modern-day color virtuoso whose strategic use of red and white in a sea of rich browns, blues, and greens feels in the spirit of Manet. Another contemporary color expert, American Lebanese painter Etel Adnan, captures mountains, sky, and oceans in abstract representation using the most perfect tan, blue, and yellow combinations.

## The Color Wheel

The first step in learning to mix colors like Adnan, Yiadom-Boakye, or Sargent is to understand the color wheel, a device that breaks down colors, demonstrates how colors are mixed, and tells you which colors create various harmonious relationships. Even after centuries of the development of this tool, the color wheel we use today remains fairly rudimentary in terms of its ability to break down color, which is an incredibly complicated thing.

Many different cultures across the world and throughout time wanted to uncover the link between the eyes and the objects that we see. But for a long time, they had no idea what that link was or how it worked. Around 1000 CE, the Arab physician Ibn Al-Haytham (known to those of us in the West as Alhazen) wrote *The Book of Optics* and was the first to hypothesize that light travels into the eye instead of the other way around, putting an end to the theory the Greeks had previously promoted. (I'm all about scientific advancement, but it must have been very cool to live in a time when people believed that light was shooting from our eyes.) What Ibn Al-Haytham correctly established is that everything we see, the entire world around us, is the result of light hitting a surface. That is why we see nothing when we are in a space with no light source. The shoes or coats that surround us in a dark closet have not actually

disappeared; we have just lost the light source that illuminates them so that our eyes can process them.

But how colors are created when light hits an object remained a mystery. Why did we see certain colors on certain objects? What even *are* colors? Aristotle had the cool, but unfortunately probably faulty, theory that colors are sent to Earth by God through celestial rays of light. In the 1600s, Sir Isaac Newton messed around with light and the color it produced and discovered that clear white light is actually made up of seven colors: red, orange, yellow, green, blue, indigo, and violet. Newton's discovery was the result of an experiment that puts white light through a triangular prism via a process called refraction, which basically means that a light ray is bent and that bending causes the colors in the white light to separate into spectrums. This refraction of light is also what happens when light travels through the moisture of a cloud and comes out the other side as a rainbow.

In the 1700s, the German poet, artist, and scientist Johann Wolfgang von Goethe built on Newton's theory. While Newton focused on the physical aspects of color, Goethe explored how our brains process the information being given to it by our eyes, the link between our optic nerves and our brains. Goethe eventually wrote *Theory of Colors*, which explores warm versus cool colors and the idea that shadows are not really black.

Then, in the early 1800s, a famous Parisian tapestry shop hired the chemist Michel Eugène Chevreul to figure out how to improve the colors of their tapestries. The ladies who lunch in Paris had grown tired of the old-fashioned, subdued colors in their textiles, colors the company worried were the result of the pigments in the fabric fading. Chevreul realized that the tapestries were not actually fading so much as appearing

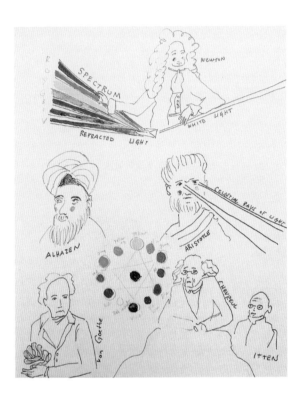

bland because their color combinations lacked distinction—an optical effect. The tapestries were made out of colors that were analogous, or very similar, to one another and when seen from a distance, the colors looked dull and faded. Nothing in the color scheme popped. Chevreul wrote an entire book on this "simultaneous contrast," the idea that colors are impacted by the colors they are located near. In this book, we will lean heavily into this idea of the power of contrasting, striking, exaggerated color combinations to bring an artwork to life.

Some art historians credit Chevreul's color theories for inspiring Impressionism and Neo-Impressionist painters to explore a new kind of

palette. The Impressionist Claude Monet said of this use of complementary, contrasting colors, "Color makes its impact from contrasts rather than from its inherent qualities . . . the primary colors seem more brilliant when they are in contrast with their complementary colors."

Some years later, Johannes Itten, a painter and a teacher at the Bauhaus, published a color theory book called *The Art of Color*. Itten pushed this theory of color contrast further by figuring out various color schemes that are harmonious together and building a modernized color wheel around them.

But before we look at the contemporary color wheel that we will be using, a descendent of Itten's wheel, we need to zoom out for a minute and look at what color processing is and how it works. We can't explore the color wheel without first understanding what color is.

## What Is Color?

Colors help us figure out the world around us. When an apple turns from green to red, we know it is ready to be eaten. When a sky in South Dakota turns a troubling greenish yellow, you better seek shelter because a tornado is coming. Yellow snow? That tells us something, too. Color is an important part of our lives.

But what is color? Color is the range of wavelengths that humans can see. When light from a lamp or the sun hits an object, most of the wavelengths in that light are absorbed by that object, but any wavelengths that aren't absorbed bounce back into the cones in our eyes, and our eyes and brain read those reflected wavelengths as specific colors.

I know that is a little hard to imagine, so let's run through what happens when you look at a banana sitting in the sun. Light waves from the

sun hit the banana, and all of those waves are absorbed by the banana and its pigment atoms except for mainly the yellow wavelengths, which are not absorbed. Instead, those yellow light waves bounce off the banana and are reflected to us. Seeing a banana is nothing more than the light in the yellow spectrum bouncing off the banana and into your eyes. (Do you hear that? That's the sound of thousands of actual scientists groaning as they read this terrible oversimplification of one of the human body's most complex processing systems. It gets worse. I'm about to start talking about the brain.)

Now let's look at what happens when the yellow light waves hit our eyes.

Our eyes are made up of a million rods and cones. Rods capture black-and-white information and work well at night but are not sensitive to color. Cones bring you information about the wavelengths and allow you to see color. The cones' job is to turn those light spectrums that have reached your retina from the banana into nerve impulses that your brain can understand. Those impulses travel through your optic nerve and into your brain, where you think, *There is a yellow banana. It is yellow, not green, so I know it is ready to eat.* (See, it got worse.)

## What Does the Color Wheel Have to Do with That Process?

The color wheel breaks down the process that scientists and artists have been studying for centuries and uses what we know about how our eyes see color to show what colors work well together. It also provides a system for mixing paint. If we want to be as adroit with color as Sargent or Yiadom-Boakye, the color wheel helps us hack into the color-processing

system happening in our brain and our eyes. The color wheel helps painters and designers understand and then apply what we know about color, wavelengths, and how our eyes and brains prefer to see certain colors in harmonious ways. It also demonstrates what happens when you add a white to a green or a blue to a red.

From complementary colors to value and shade, the color wheel holds the secrets to our exploration of color. And, as we progress, the color wheel will become a decision-making tool. Painting is all about making the right decision when you are contemplating the many choices you face at the various stages of your artwork. The color wheel helps you make the best possible decisions when standing in front of your canvas.

A color wheel does these things well:

- Tells you which colors naturally work well with one another
- Guides you when mixing a color with white, gray, and black
- Serves as a color cheat sheet to help you figure out how to mix the colors you want

## What Is on a Color Wheel?

You've probably seen a color wheel, but do you really know what's on it or what its purpose is?

Colors (also called hues): Ten colors arranged in a circle in the order they are in the spectrum and in relation to how long their wavelengths are.

Primary colors: Everything starts with red, yellow, and blue. These are the pure, unmixed colors.

**Secondary colors:** Green, orange, and violet are the colors you get by mixing together the primary colors in different varieties.

**Tertiary colors:** These colors combine one primary and one secondary hue.

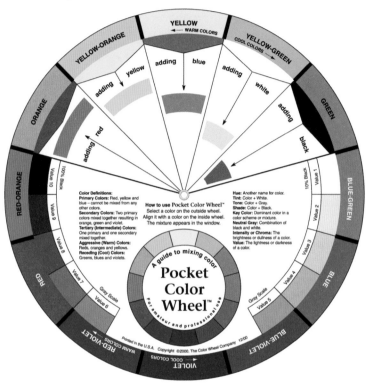

NOW LET'S EXPLORE THE COLOR WHEEL.

Look at the side of the color wheel that has colors running along the edges. That side is all about color mixing. It features the warm colors— red, yellow, and orange (think warm sun)—and the cool colors—blue, green, and violet (think cool water).

Also on that side of the wheel is a grayscale, which helps you figure out where a particular color lands in terms of its value, or how light or dark it is. We will get into light and shadow later.

This side of the color wheel is also where you go when you want to know what will happen if you add blue to orange or yellow to blue. And it shows you which colors are next to each other on the spectrum. The placement of the colors on the spectrum is important to know because we will be looking for naturally harmonious color relationships, and any colors directly next to each other on the wheel, called analogous colors, work well together.

Let's flip over the color wheel.

This side of the wheel is labeled "Illustration of Color Relationships or Harmonies" and serves a few purposes. It shows you what happens to a color when you add white (you create a tint), gray (you create a tone), or black (you create a shade).

In the center of this side are a few line drawings of shapes like triangles and rectangles. When you rotate the color wheel, those line drawing shapes line up with various color combinations or schemes. Those combinations are also naturally harmonious. Some of those various color schemes on the circle include the following:

> **Complementary:** Complementary colors are the two colors located directly across from each other on the color wheel. As Chevreul discovered, this is the most powerful color relationship because it has the highest level of contrast and impact due to the opposing wavelengths of the colors. For example, yellow and purple (or violet) are on opposite sides of the wheel and are complementary colors. Yellow has a longer wavelength, and the

purple wavelength is shorter, and in the amount of time that it takes for the yellow wavelength to arrive versus the amount of time it takes the purple to arrive there is an ultraminuscule delay that creates a sense of tension when you look at the two colors together. That tension is very sexy to our eyes.

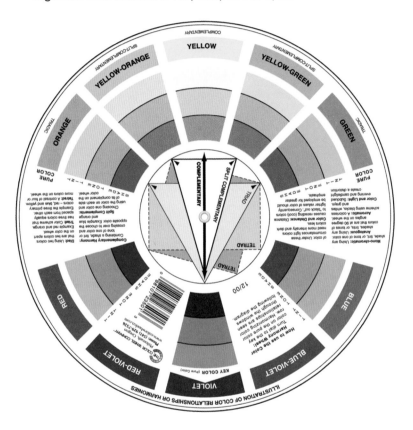

You could spend your entire life painting just red/green, blue/orange, yellow/purple paintings and make amazing paintings. Some of Van Gogh's most beloved paintings use the complementary colors orange and blue.

Think of complementary color combinations as the visual equivalent of a duo singing in perfect harmony. If Paul Simon's voice is yellow, Art Garfunkel's is purple. Aaron Neville is red, and Linda Ronstadt is green. The contrast between their voices is naturally attractive to our ears.

We see a lot of complementary colors in nature. Think of a yellow moon at a purplish gloaming hour. And Mother Nature gave that red rose a green stem so it would attract pollinators.

This use of complementary colors sets modern, avant-garde art apart from earlier art, which was more than happy to use more subdued, less dramatic relationships. Or, if they were looking to create drama on their canvases, earlier Western painters like Caravaggio and Rembrandt focused on drastic shifts of dark and light rather than dramatic color relationships.

**Split complementary:** This scheme uses the two colors on either side of one of the complementary colors. For orange, you would use the two colors on the side of its complementary color, which is blue. That split complementary scheme would be orange, blue-violet, and blue-green.

**Triad:** This scheme is built by the three colors that form a perfect triangle together. So orange, violet, and green or red, yellow, and blue.

**Tetrad:** This scheme uses the four colors made up of two sets of complementary colors, which creates an X on the color wheel.

## Time to Paint

Let's get out our paints and practice playing with color. In my painting classes, the first time people get out their paints can be stressful. So turn on some of your favorite music, grab a cup of tea or a glass of wine, and approach this with an acceptance of inevitable mistakes. Focus on enjoying being creative; don't focus on creating a perfect artwork. (There is no such thing.)

### GENERAL MIXING TIPS:

- Mix small bits of dark color into larger bits of lighter colors, not light into dark. It is a lot easier to turn yellow to green by adding a little blue to yellow than it is to make green by adding bits of yellow to blue.

- Adding a tiny bit of white makes color straight from a tube stand out more.

- But don't try to lighten colors by adding white because that can create a dull color. Use a lighter version of the same color instead. For instance, use naphthol red light to lighten cadmium red.

- When making colors darker, don't automatically reach for black. Try making a red darker with a little blue or making a green darker with a little red.

- The more colors you mix together, the more muted your color will be. Three or four colors is where I stop unless a muted color is my goal.

- Don't dilute acrylic paint too much, unless you are trying for a wash effect.

- Mix like with like. Mixing a warm color with a warm color and a cool color with a cool color results in more brilliant colors. Mixing a warm version of a color with a cool version of another color results in muddier colors. There is an entire chapter on cool versus warm in this book, but for now, if your colors are muddy, that might be why.

- Use all of your paint! If you only have five minutes left to paint but you still have wet paint on your palette, grab a piece of paper and do an energetic abstract painting with your leftover paint, or use it to paint the background on some blank canvases. The artworks I make in the final moments of a painting session are often my best. They are more fearless, more energetic, and less contrived.

# Exercise: Experiment with Paint

Mixing paint is the most fun, and most challenging, part of learning to paint. Paints are expensive, so just like all the other things that do not grow naturally from the ground and eventually wind up in a landfill, you don't want to waste them. This means learning how to use them well.

Let's mix a few colors so you get used to the feel of the paint and brushes. For this exercise, use a medium-sized brush.

Your first step is to open your paints and put three small, dime-size dollops of yellow, red, and blue paint onto the edge of your palette. You can always go back for more.

Let's mix your secondary colors (purple, orange, and green) first.

Remember to always add a tiny bit of the darker color to the lighter color. Start by using your brush to dig out a little bit of yellow paint. Put that paint into the middle of your palette. Take a tiny bit of blue onto your brush, and mix it into your yellow. Keep adding more bits of blue until you get the green you desire. Blend the paint by mixing it in tiny circles until no streaks of the individual colors remain. If you are a baker, this moment is equivalent to when the dry ingredients become totally combined with the wet.

Do the same thing to make orange: add small bits of red to the yellow, blue to the red, etc. Once you have those first six colors on your palette (red, blue, yellow, orange, green, and purple), let's paint.

# Exercise: Paint an Orange That Pops

You are going to paint two orange circles with the goal of making that orange pop as much as you can. What kind of background could you paint to make an orange appear to jump off the page? I would go for the strongest complementary combination and paint the background blue.

If you paint a blue or other cool-color background, notice how the orange seems to float off the page. The orange wavelength is longer than the blue wavelength, so it hits your eyes first, making it seem like the orange is emerging from the page. This understanding of wavelengths will become important in later chapters when your goal is to make your paintings have depth.

If you decide to paint a warm background, the orange won't pop from the page that much because the wavelengths are arriving at your eyes close to each other.

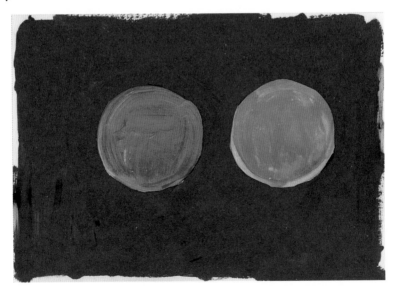

Color Wheel / Mixing Paints

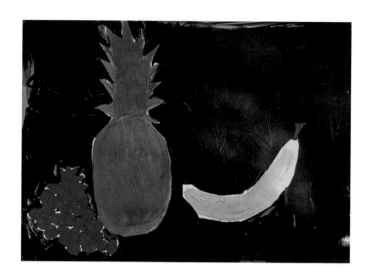

## Exercise: An Analogous Color Fruit Painting

Build a still life using any fruit you have around—a banana, some grapes, a cherry or two, an apple. Line three fruits in a row without them overlapping.

Look at your color wheel, and pick three side-by-side, or analogous, colors (red, yellow, and orange or green, blue, and green, etc.).

Let's say you are using the analogous colors red, yellow, and orange. First you need to mix orange. Put a bit of yellow in the middle of your palette, and add small bits of red to it until you have the orange color you want. You can mix a few different shades of orange. Maybe one with more red in it and one with very little red. Maybe mix one yellow with a bit of orange in it, one orange with a bit of red in it, and one with a little more red in the yellow than you did with your original orange. You should have a few reds, an orange and red-orange, and your yellow.

Now sketch out your three fruits with a pencil or a bit of paint on your smallest brush. Don't worry about making perfect shapes; you just want the general form. Make the banana one color, the grapes one color, and the stem another. Your final piece of fruit can be whatever color you haven't used yet and then take one of the remaining colors to paint the background. Congratulations! You just painted your first analogous painting and your first still life.

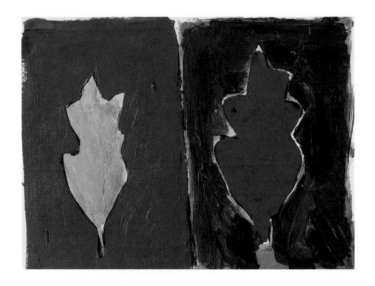

## Exercise: Study Complementary Colors

On a new piece of paper, draw a line down the middle to separate the paper into two parts. Then draw a smaller shape inside one of those rectangles. The smaller shape could be a square, a circle, a diamond, or any shape so simple that it is not a lot of drama to paint it. Then repeat that exact shape on the other side of the paper.

Let's say your smaller shape is a leaf. Paint the leaf on the left side red and the leaf on the right side green. Then, paint the larger space on the left painting green and the larger space on the right side green.

Notice how in both paintings the green shape seems to go farther back into the page; it recedes. The red shapes move forward in space. On both sides of the page there is a tension, almost a vibration, between the two complementary colors. If you have the time, you could do this same exercise with all three of your complementary color sets. If you put all three paintings in a frame, you have a cool abstract work of art.

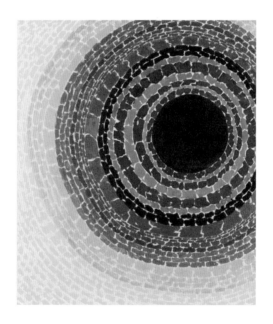

## Exercise: An Alma Thomas Painting

Alma Thomas is one of my favorite painters. My two favorite things about Thomas's work are how it was inspired by uplifting moments like

landing on the moon or the flowers blooming outside her window and her bold use of color.

Her art consists of energetic, repetitive brush marks and strong color choices, which we will be mimicking in this exercise. We will attempt Thomas's radiating circle, like a sun with beams of light emitting from it, or maybe it's ripples in water from a stone being tossed.

Like Alma Thomas, we will focus on making beautiful marks with a healthy amount of paint and not too much water in our brush. And, like Thomas, I want you to try to be confident when dabbing the paper with the brush.

For the radiating circle painting, pick one of the lower value colors like purple or blue and put it somewhere in the middle of the page. Work your way out to the corners of the page, getting warmer as you go. There is no right way to do this. Just don't push too hard on the brush, and try to wash your brush well between each color so the colors stay nice and bright.

## Exercise: A Carmen Herrera Painting

Carmen Herrera is a Cuban-born American painter who is one of our greatest color field painters. To paint like Herrera, you need to be controlled and patient. We will be using masking tape to create a straight line because Carmen Herrera famously said, "I never met a straight line I didn't like."

Choose two primary colors (yellow, blue, red) or secondary colors (purple, green, orange). You will need some masking tape, and you may choose to use black.

Use the masking tape to create some sort of line through the middle

of your painting. The line can be straight across, diagonal, or a lightning bolt shape. Paint half of your page one color (primary, secondary, or black), and carefully remove the tape. Let the paint dry completely; if it is still tacky, this won't work. When it is totally dry, tape the painting again, but this time, tape off that line so you can paint the empty side of the canvas a different color (primary, secondary, or black). Remove the tape, and let the paint dry.

Is there energy between the two colors? If your answer is yes and you like your piece, leave it. But if the painting doesn't feel interesting yet, let the paint dry again, tape off a new shape on top of the existing color relationships, and paint that new shape your third color. Remove the tape and look at how the shapes and colors are now relating. Are there any nice bits of tension where the tip of one shape almost, but not quite, touches another? Does your green and red combination feel like it is vibrating? If not, don't worry. Painting is experimental. Start over with three new colors and shapes. Keep experimenting until you make a painting you love.

You might decide that you do not like this kind of rigid painting. I don't like to paint like this. You might like a more messy process. Or, you might really enjoy this painting of straight lines with tape. Pay attention throughout the book to which exercises feel good to you. They are keys to what direction you might want to go with your painting.

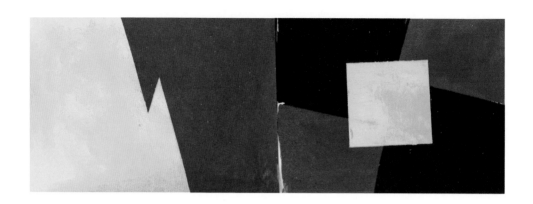

## Exercise: Masterpiece Color Hunt

Grab your favorite art history book, or check out a library book full of paintings. Use your color wheel to match colors on the painting.

Look for any of the harmonious color combinations in the paintings. Does the artist use any tetrad color combinations? Any split complementaries?

Which paintings in the book stop you in your tracks? What characteristics do those paintings share? You might start noticing that some of your favorite colors are mixed with gray or yellow. Maybe you love dark shades with a burst of light or Renoiresque pastels. The colors that pull you in are also something to notice as you move along.

## SHAPES & COLOR

t is regional folklore that my great-grandfather J. T. Jorgenson was the second white man born in the Dakota Territory. Others say he was the fourth. Either way, before I understood what the arrival of my ancestors meant to the Indigenous people already living on that land, I used to brag about my long Dakota roots.

But it is a fact that J. T.'s mother, Annie, arrived in the Dakota Territory with a covered wagon full of kids and twin infants in her arms. It is true that they dug a hole into the side of a hill, topped it with sod, and proceeded to live in it, sharing the space with their livestock and the total of eleven kids Annie eventually had.

J. T. was born in 1870, around the same time that the Secretary of the Interior began to systematically kill the buffalo in order to cut off a primary part of the food supply of the Indigenous Americans. This slaughter meant that the Lakota people's traditional source not just of food but also of clothing, tepee covering, and decoration disappeared.

This resulted in Lakota quilters adopting the cloth quilting that European missionaries brought to the prairie. The lone star pattern in their star quilts is inspired by the Morning Star, which was seen as a link between people who have passed and the people they left behind on Earth. The star quilts have always been a huge part of Lakota traditions and remain so today. Given to those being honored, they're placed on the shoulders of hunters or warriors returning from a battle or a hunt. They also mark rites of passage and are draped onto the shoulders of recent graduates or brides and grooms during wedding ceremonies. A beautiful aspect of the Lakota star quilt is that it is intended to be gifted.

Just as the star quilt carries on Lakota symbolism and rituals, all quilts serve as conduits of history.

Enslaved Africans brought their long history of textile art with them to America, as well as their artistic tradition of fusing long strips of bright fabric to create complicated geometric patterns. Some people believe that quilts were hung on clotheslines or in windows so the iconography sewn into them could direct slaves along the Underground Railroad. The Smithsonian Museum has a quilt created by Harriet Powers, a freed slave who filled her stunning work with both Bible stories and current events, like the time in 1833 when people saw a meteor shower and thought the falling stars signaled the end of the world.

Quilting was one of the countless domestic duties women were required to do, but quilting was not always just another chore. For some women, making quilts went beyond creating utilitarian items to warm beds, provide privacy, or block the winter wind from blasting through a door. Making quilts served as an artistic release. Quilting helped keep

housewives sane in the face of the often mind-numbing monotony of their massive workload. It was a way to tell their own stories.

Consider this windmill blades pattern in a quilt my mother created, influenced by the windmills that white quilters on the prairie installed on their farms and ranches.

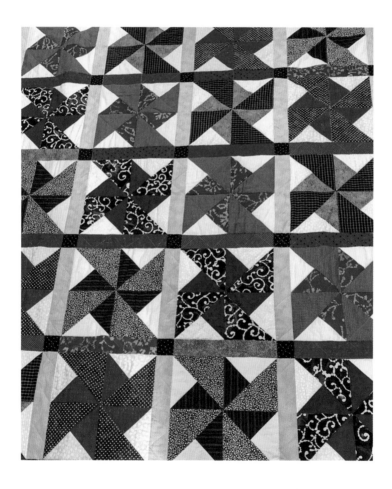

With water sources miles away, windmills pumped water to the surface and played a crucial role in survival on the ranches. The use of the pattern symbolized both the isolation of the quilters' homes and the wind of the prairie. If you haven't been to the Dakotas, you should know that the wind is one of the area's defining characteristics. It blasts you with a shocking heat when you get out of your air-conditioned car in August, and it freezes your lungs and nose hairs when you leave your house in January. That relentless wind also had an impact on the mental health of the women living there when the dust storms hit in the 1930s. My grandmother, who lived on the Dakota prairie during the Great Depression, told me of the ominous sound of the walls of dust approaching her family's ranch as they tried to plug the gaps in the windows and doors with quilts and rugs.

Some women even became emotionally undone by the sound of that wind.

The writer Dorothy Scarborough wrote a book about this so-called "wind madness." *The Wind* is the story of a young girl who moves from Virginia and all its shade trees to barren, windy West Texas. The novel was made into a 1928 silent film starring Lillian Gish, and I wonder if my grandma, a child prodigy pianist who accompanied silent films on the piano while still in grade school, ever accompanied that film. She could have; she would have been ten when *The Wind* came out. If she did, I wonder what she thought as she played dramatic music to a film about a place just like where she lived where a woman could come undone by both the sound of the wind that blew across it and the role she was expected to play there.

MY MOTHER IS A WONDERFUL QUILTMAKER. As the grand-daughter of J. T., she is prairie born and bred, descending from the white women who arrived in the Dakota Territory and adopted the Lakota's star quilt pattern. The white women also designed their own quilt patterns with fascinating names that, like the windmill pattern, reflected the domestic and spiritual lives they lived: prairie queen, broken dishes, grandmother's fan, and courthouse steps. My mom often uses the log cabin and starflower patterns, and her quilts keep my kids warm and beautify my house.

My mom's quilting supplies and sewing paraphernalia fill a quarter of our basement. The old scraps of fabric and yards of new fabric are neatly folded. A spice rack holds spools of thread. Images from magazines are pinned onto a cork board for inspiration as are the tools light enough to hang on a thumbtack. There are spray adhesives, bobbins, many pairs of shears, and tiny scissors. On a long table she lays out her fabric and keeps longer measurement tools, straight edges, and a huge cutting board where she cuts fabric and experiments with various color and shape combinations.

When I was growing up, I never thought of my mom's quilting as making art; I thought of it as blanket making. I also assumed that she made quilts partially because it allowed her to reuse the pieces of fabric too nice to be relegated to the wicker rag basket with our threadbare underwear and socks full of holes.

But the fact is that no matter how common the materials she used were, or how utilitarian the final product was, every day I watched my mom make art. I watched her select a color, cut out a shape, and manipulate the relationships of colors and shapes in order to find the most impactful compositions. I went with her to the fabric store and watched as she walked the aisles, feeling fabrics and considering patterns. Through all of that, she was teaching me about the most important parts of making art.

I had no idea how closely linked my paintings and her quilts were until the day I stumbled upon a show at the Whitney Museum of American Art of quilts made by a collective of artists from a tiny town named Gee's Bend in Alabama. After growing up in a house where quilts lived on beds and the back of couches, seeing quilts exhibited on the walls in such an austere setting was a shift of context—my mom's quilts were no different than my paintings.

The Gee's Bend quilts are as complex, bold, and colorful as any paintings created by contemporary artists like Stanley Whitney, Frank Stella, Etel Adnan, or Carmen Herrera—artists also on the hunt for the ultimate placement of one colored shape next to another. And some of the squares in the quilts looked nearly identical to the color studies of Josef Albers, one of the most respected color theorists. It is no surprise that Albers's work was considered genius, while the similar work being done in Gee's Bend was not. The artists who got famous for work centered around shape and color back when my grandmas and mom were making quilts were almost exclusively white males, while the women around the world, especially the women of color, perfecting the same color theory basics remained anonymous.

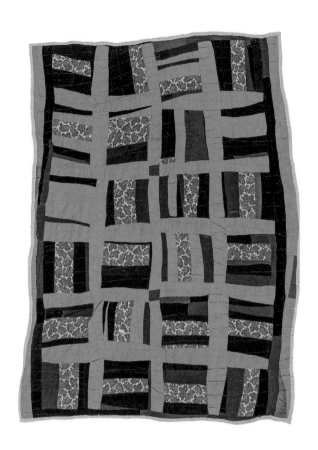

QUILTS ARE AMAZING PROOF POINTS OF A KEY TRUTH ABOUT
PAINTING: COLORS EXIST IN RELATION TO OTHER COLORS.
A red next to a blue is very different from a red next to a green. They also
show how repeating a pattern in certain colors creates an energy. Quilters
and painters know the same thing: combustion is possible by putting a
certain color in a certain shape next to another colored shape. This search
for a tense, striking, or harmonious relationship is also one of the cores
of making a painting. A perfect color combination is exactly why look-

ing at a Stanley Whitney or a Mark Rothko painting is so thrilling. And it is why Matisse's work is so powerful.

"I don't paint things," Matisse said. "I only paint the difference between things."

Years ago, I visited the Tate museum with my friend Alan, a painter who lives in London. He brought me to his favorite room, which holds nothing but paintings by Mark Rothko.

The room was quieter than the rest of the museum, and the lighting was dimmed as per Rothko's instruction, so it felt like visiting a chapel. But there was enough light to see how the pigments in the paintings bled into one another and softened the edges of his marks, like a brand burned into a cow's hide. A vibrant red, not far from orange on the spectrum, stained a square into an oppressive dark burgundy. Murky lavender wrapped around a floating black the color of a storm cloud. Blood orange red leaked into the edges of a wretched gray. Rothko's paintings were sad portals to some extra depressing realm. Their mood settled into Alan and me so we sat down on the bench in the middle of the room. I fought off tears as I stared at the work. I didn't need to know the terrible backstory of the collection to feel that here was a despairing artist making haunted work, but there was a terrible backstory.

The paintings were originally commissioned for the expensive and iconic New York City restaurant The Four Seasons, with Rothko's goal "to ruin the appetite of every son of a bitch who ever eats in that room." After he completed the paintings, Rothko decided that he didn't actually want those fat cats to enjoy his art and he sold them to the Tate instead. On the same day that the paintings arrived at the London museum, Rothko committed suicide in New York.

If the quilts are proof of the power of color and shape to tell a story and give us personal histories using dynamic color combinations, Rothko's paintings are proof of the opportunity for color and shape to make you feel the emotion that went into their creation.

## Shape & Form Exercises

Art is made up of components that we call the "visual elements." Those elements include line, color, value, space, form, texture, and shape. Mastering the visual elements will help you have painting success in the future because every painting on the planet is nothing more than some collection of those things.

This chapter focuses on two of those elements, shape and form. Shape and form are the building blocks of any painting, figure, or landscape.

### Shape Versus Form

Shapes are exactly what you think they are: triangles, squares, circles, amorphous blobs and drips, and anything else two-dimensional. When you were little and you drew a house using a square for the building, a triangle for the roof, and a rectangle for the chimney, you made art with shapes.

Form is what you get when you turn a shape from two-dimensional to three-dimensional. A shape is a triangle; a form is a cone. A shape is a square; a form is a box. Form is when those shapes on your childhood drawing became three-dimensional and the house got two walls, the chimney became a box, and the triangle was given a sloping side.

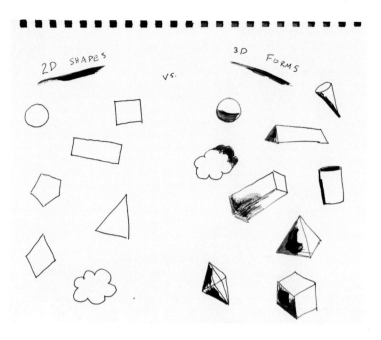

But don't think that using form in a painting is better than using shapes just because it is more complicated; it is just two different approaches to making art. From Egyptian art to Islamic art to modern-day color field painters, great two-dimensional painting has a long, impressive history.

Arthur Dove, an American painter and one of the country's first abstract artists, did simple landscapes with circle suns, clouds shaped like you expect a cloud to look, and triangle ocean waves. His work demonstrates that when you simplify the shapes, color relationships become even more important.

The American painter Albert Pinkham Ryder created psychological paintings in a dark, moody palette using triangles as ship sails.

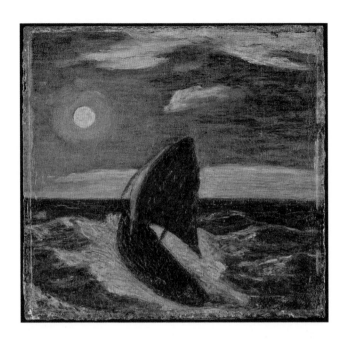

The artist Clementine Hunter used simple shapes or two-dimensional silhouettes of people, churches, and pine trees to depict life for Black Americans in the South. Charles Sheeler helped found the American modernist movement by turning triangles into ship sails and cylinders into grain silos. In modern art, this use of color and shape became known as "abstraction" as Wassily Kandinsky filled his canvases with diagonal lines, circles, and zigzags, brightly colored and energetic, crossing each other, until his paintings resembled some scene from outer space or a cover of a sci-fi novel.

Sonia Delaunay, one of the first abstract painters, made work relying heavily on repeating arcs and circles of many different colors. Joan Miró and Alexander Calder both did simple, magical paintings that were

nothing more than circles and lines. The dynamic interplay between those shapes is what gave them energy.

Navajo artists use two-dimensional shapes of lightning bolts and zigzags in their blankets.

Ellsworth Kelly used boxes of color, and, like Herrera, the interaction of color is the star of his show. Piet Mondrian became famous for painting colorful grids and boxes, and Georgia O'Keeffe cloud paintings contained shapes so simple they could have been created by a child. Carlos Zinelli made paintings of simplified warriors, while Yayoi Kusama makes endless repetitions of polka dots, mushrooms, pumpkins, and eyes. Su Xiaobai is a modern-day Mark Rothko, creating emotional relationships of color. The Philippine American artist Pacita Barsana Abad used swirls of color and bold shapes to form giant masks and cosmic scenes.

## Exercise: A Virtual Hunt for Shapes

Return to your art book to seek out paintings in which artists work with two-dimensional shapes. Notice where your eye is drawn because of something interesting happening between two colors or two shapes. Is there tension there? What shapes do you notice beyond squares, circles, and rectangles?

## Exercise: Three Silhouettes

To make these silhouette shapes, reject any attempt to capture the wrinkles, loose strands of hair, shadows, or any detail of the object you are painting. You want to make recognizable two-dimensional silhouettes.

Choose three treasured items from your home to practice painting. You could, of course, pick not-treasured items like an apple or a shoe, but you will have a painting with a lot less meaning. You could select a vase that you inherited from your grandma, a figurine of a dog, a rosary, a bowling trophy, or anything that can be simplified. I used a wooden bird; a Virgin Mary plastic Holy Water bottle I brought back from Lourdes, France, for my grandma; and my daughter's softball trophy.

For this exercise, let's focus on the decisions that go into creating a painting. We won't do this decision breakdown in each future exercise, but doing so here will help demonstrate how a good painting comes to be because of a series of smart decisions.

Your first decision: What color scheme will you use? Complementary? Tetrad?

Your second decision: What color should your background be?

You can leave your background the white of your paper, paint it a

color, or paint it black. If you have a color scheme that you know you want to paint, like a monochromatic scheme or a tetrad, paint the background one of those colors. You can paint the background first or paint it after you have painted your images.

Your third decision: What order should your shapes be in?

Play with your objects. See if one arrangement looks more interesting. If you are painting a teapot with a spout, the fact that the spout is a shape that directs out into space should make you think, *Do I want to direct that shape toward another shape to create tension? Or would it be more interesting to use that spout to direct the viewer's eye off the page?* If your objects have three different heights, should the shortest object be in the middle with the taller objects on either side, or should the objects be arranged in order of ascending or descending height? There is no correct answer here. This is about what seems more balanced to you. Move your objects around to see what arrangement looks best.

Your fourth decision: What colors should your objects be?

If you are using a specific color scheme from your color wheel, begin by mixing those colors on your palette. Let's pretend that your color scheme is the split complementary blue-green, orange, and blue and that you are painting your background black. There is no "correct" way to choose which object is which color, but each combination will feel different. Make your choice, and see how the colors interact. You could paint three different versions, with three different color arrangements, and explore the different energy of each version.

WHAT ORDER SHOULD MY SHAPES BE IN?

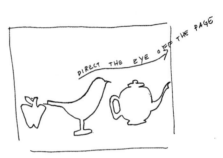

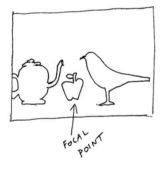

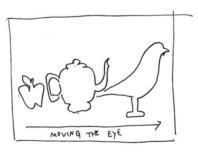

Your fifth decision: How much of your space will the shapes occupy?

Your shapes could be large and fill as much of the page as possible, leaving little space between the sides or the top and bottom of the page. Having your objects jammed together will create an intense, claustrophobic composition. Or, you could draw very small shapes that float in the middle of the page with lots of negative space around them, which is a different kind of energy. Again, no right answer here.

## Exercise: Black Silhouettes with One Detail

Use the same three shapes as in the previous exercises, but this time, make the three silhouettes black on a background of any color of your choice or on the white of the paper. You can paint the objects any scale and in any order that you want. When you are done with that, add one small detail to each figure in a color or white. If it is a figurine of a little boy, maybe you sketch in the rim of his hat or the shape of his eyes. For the teapot, a small line could represent the opening to the spout. If you

are painting a bird, add a line for the wing. This painting will be in the spirit of the simple art that Pablo Picasso and Matisse painted of birds, cats, and other animals.

There is a good chance that in front of you is a fairly decent painting. If you don't think it is decent (I know that I am more critical and unreasonable right after finishing a painting than I am when I look at it a month down the road), I suggest putting it aside and taking it out at a later date. At that point, you will either realize that you did create a nice painting or you will still think it is terrible and you can use the additional skills you have learned over the past month to paint over it.

As you build your capabilities and confidence, one mark at a time, these decisions, which are now pretty labored, will become more instinctive.

## Exercise: Speed-Paint Many Silhouettes

This exercise involves three quick paintings done in three minutes, five minutes, and ten minutes. Get out three pieces of paper, and put a variety of small amounts of paint on your palette. By having to quickly fill the page, you won't have time to obsess over what goes where. Instead, you can play with space and relationships. You will need a timer.

First speed-painting (three minutes): Paint as many line drawings of the three objects as you can in three minutes. Do not fill in the objects; use your paintbrush to capture just the outline of the shape in line form. Notice how tilting the object or turning it on its side makes the painting more interesting.

Second speed-painting—silhouettes (five minutes): Pick one of your objects and three or four different colors. Get a new piece of paper, set

your timer for five minutes, and do as many silhouettes of that one object as you can in five minutes. The object of this painting is to leave as little of the negative space on the page as you can without your painting looking messy. You can tilt your object, turn it upside down, make some tiny, and make some large. You could crowd one corner with objects or cluster them in the middle. The real fun in painting shapes is filling the page with them.

Third speed-painting—objects with details (ten minutes): Fill the page with different colored versions of the objects to create an interesting painting with varying color and shape relationships. Spend more time painting your objects and considering how you want your painting to look. Note what happens when one color is directly next to another and when one shape makes contact with another. Are there any points in your painting where interesting tension is emerging? Add a few small details like you did on the black silhouettes.

## Exercise: Monochromatic Fruit Painting

A monochromatic color scheme means that you stick with one color and paint different values of it. A red monochromatic painting uses only red, pinks mixed with red and white, mauves mixed with gray and red, and the dark red color created when red is mixed with black.

Grab three pieces of fruit with different shapes, maybe a bunch of grapes, an apple, and a banana. You can also paint from memory or an image if you don't have fruit in the house.

Sketch out the three pieces of fruit with a pencil or paint using a smaller brush. Again, this is a silhouette, not an in-depth study. Pick the color you want to explore with tint, tone, and shade. Paint each piece of fruit a different value. The banana could be a pale pink; the grapes a mauve; and the apple a dark, dark red. Then, you could pick another version, maybe an even paler pink or darker red, to paint your background.

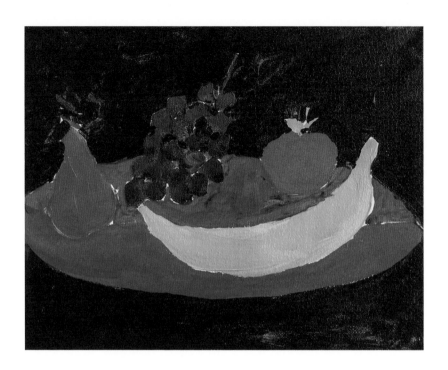

## Exercise: Paint a Sphere

To move from painting shapes to painting forms, you have to learn two
things:

> **1. Shading:** Representing the shadows that light creates will
> help you give your objects form.

> **2. Perspective:** Make a flat object look three-dimensional by
> making it appear to move back in space.

Get two round objects like oranges, golf balls, ping-pong balls, or
grapefruits. You need your black and white paints and a light source like a
bedside lamp, the flashlight on your phone, or anything you can bring

close to the objects. You will need to create a clear differentiation between the light from the light source and the shadows that light casts. You can't get that clear differentiation by relying on the light source in the ceiling.

Put one of the round objects closer to the light source than the second object is.

Observe how the light and dark appears on each round shape. Where is the brightest spot on the two balls? It should be on the ball closest to the light source on the side closest to the light. This is called the highlight.

How do the shadows on the ball closer to the light look compared to the ball farther away? Where is the darkest spot on the two balls? It should be on the ball farther away from the light on the opposite side of the light source. That is called a core shadow.

Between the highlight and the core shadow is a range of shadows. Try to count how many different areas of shadow you see. If your light source is very close to the ball or is a very direct light source, the difference between the light and shadow will be stark and you won't see a lot of different shadows. There can be an almost distinct line where the light ends and the shadow starts. That line has an amazing name—the terminator line.

If your light source is far from the balls, the shadows will blend more, and you will see a variety of nuanced, more subtle shifts in light and dark.

Then there is the cast shadow, or the shadow the ball makes on the surface that it sits on.

Let's draw the two balls using a pencil. Don't worry about composition; just ensure there is room on your paper to add the cast shadows under the balls.

Draw the shape of the lights and the shadows on your balls. Maybe

the shadow is a half moon, or the highlight is shaped like an ellipse. Is the sphere split in two by the shadows with one, stark curved line? Or is there one clear differentiation?

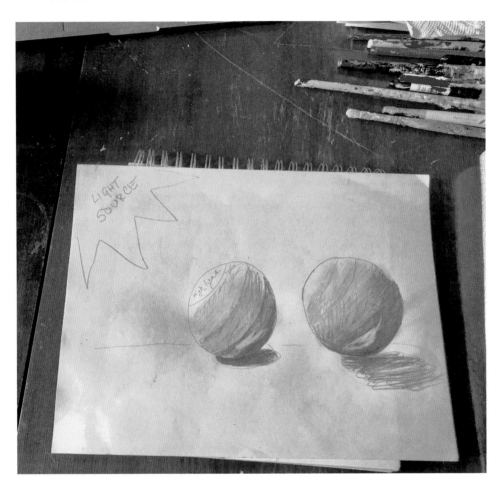

PAINTING CAN SAVE YOUR LIFE

Keep sketching out the shapes of the shadows and light until you have the general count of the number of shadows on each form. Then you know how many different shades of gray you have to mix. Let's say you have four different levels of value on your balls. For a high value closest to the light source, put just the tiniest bit of black into the white. Then mix a shade slightly darker. Keep mixing darker shades until you think you have four shades in the range of shadows on the balls. You could even hold up swatches of paint next to the actual shadow on the balls to see how close you are.

Now apply that paint to the shape that matches its value. When you finish painting each of the shadow shapes on the balls, you will have turned a two-dimensional shape of a circle into a three-dimensional form. The sense that the round shape is curving into a ball should emerge because you captured how light and shadow hit a form and give it depth. Now you know that painting form is really just closely observing how light hits an object in order to make it look three-dimensional.

# FILLING THE SPACE (SPACE & COMPOSITION)

When I was twenty-three, I drove with my friend Betsy to Toulouse, France, to get a tattoo from a guy named Eskimo. We were working as camp counselors in a tiny town in the Pyrenees Mountains and had been given the camp car to drive to Toulouse to buy more softballs. Knowing that it was 1994, and that I was an extremely generic American twenty-three-year-old, guess which of the three most obvious tattoo options I got: (A) dolphin, (B) sunflower, or (C) butterfly.

(B) Sunflower.

I was nearing my peak pretentiousness in 1994, so I told people that my tattoo was not just some generic selection. Rather, it was a demonstration of a mathematical theory called the golden mean, a ratio of 1.618, frequently found in nature in symmetrical things like seashells and sunflowers. Some believe that the Ancient Greeks used the ratio to make the Parthenon so pleasing to our eyes.

The idea of such symmetry living forever on my hip appealed to me, but the other reason I got a sunflower, and a reason much more on brand for me, is that a boy told me about the golden mean as we stared at a field of sunflowers in Greece, not far from the Parthenon. Then he told me I should consider striving for such symmetry in my compositions the next time I painted.

Luckily, my husband provides less unrequested guidance on my art. He rarely risks voicing an opinion on a painting in progress lest my head spin all the way around, my body levitate, and green sludge fly from my mouth.

But he is a very skilled artist, and occasionally his opinions about art come at me sideways as he claims to be talking about the artwork of somebody else, but the specific nature of the comments make them feel very much intended for me.

"I don't know why she doesn't spend more time improving the things she is drawing," Rob might say. "Doesn't she want to draw a better body or a better tree?"

*Wait a minute . . .*

"I feel like he just never learned the basics of filling a page."

*Hmmm. . . .*

"If you are going to paint, I feel like you should have some sense of what a strong composition is. Or at least not use the same composition over and over again."

*That one, without a doubt, was directed at me.*

When I first started painting, my idea of a strong composition was to repeatedly put a single object in the center of my page. I reused that same composition over and over again. Looking back, it was quite the cop-

out. It saved me from making many decisions, and I didn't have to gain the skills necessary to paint more complicated compositions.

But when I married a perfectionist, a craftsman who never leaves well enough alone, I set out to try to improve my work with a similar eye toward excellence. I studied composition and space, beyond the golden mean on my hip, beyond the solitary object. I looked at great artists to see how they did magical things within the narrow boundaries of a canvas. How did Frida Kahlo fill her canvases with so many symbols, patterns, and colors without making it messy? When Egon Schiele is so stingy with his lines, and so much of his page is negative space, why are my eyes still engaged with the entire page?

I had a lot to learn.

Filling the Space (Space & Composition)

SIX YEARS AGO, I BEGAN BUILDING OUT THIS TEACHING METHOD. In order to break down the act of painting so I could better teach it to others, I became a student again, reading every book, magazine, and newspaper article on movements, techniques, and artists. I searched for clues about the artistic process in biographies. I watched BBC and Art21 documentaries. I went to countless art shows. The side product of learning all I could in order to teach painting is that my own work improved exponentially.

One more reason to take on painting? You can always get better.

## Exercises

Your paintings will contain two types of space:

> **Positive and negative space:** Positive space is the area where your objects are. Negative space is the space that surrounds those objects.

> **Deep space:** The space as it moves back into the canvas, deep space includes the foreground, middle ground, and background.

People fill a canvas in so many ways. Some composition choices are related to current trends, and others are in tune with traditional patterns. There are so many ways to make engaging compositions, like the studies of life and battle found on the ledger paintings of Lakota artists, the graphic perfection of the paintings in Jacob Lawrence's *The Migration* series, Yayoi Kusama's repeated pumpkins and polka dots, the contem-

porary artist Rose Wylie's seemingly chaotic world of giant dogs and princes, and Joan Miró's singular way of filling his canvases with weird symbols and free-floating eyes.

When it comes time for you to fill a canvas, it helps to know what a painter's job is when creating composition.

**Give the viewer somewhere to look:** You can direct their eyes to a focal point using light, color, or composition. Or, rather than having a single focal point, you can move their eyes around the painting by considering which ways to point the various objects in your painting.

**Create balance in your painting:** Composition is the hunt for balance. You want to strategically use positive and negative space as well as shadows and light to create this balance. The balance might happen through symmetry, an innate sense of

balance, or it might happen through some sort of asymmetry, which is a dramatic use of the page. Some people map out this balance before they start painting, and other painters, like me, wing it as they go along.

## What Makes a Good Composition?

You already started thinking about composition in the earlier exercises when you played around with whether your treasured objects would be large or small, fill the page, or cower in the corner. Let's go further and learn about the elements of a strong composition:

Proportion: This is one object in relation to another object in terms of size. A huge moon next to a tiny gorilla versus putting a massive gorilla next to a tiny moon are two completely different senses of space and two very different compositions.

**Movement:** This is what we were thinking about when deciding which direction the spout of a teapot might point. Movement can guide the viewer's eye. The bend of a dancer's body or a goose flying diagonally up across a canvas also moves our eyes.

**Contrast:** A contrast between certain colors or values, or darkness and light, creates a focal point or draws the viewer's eyes toward an object.

**Pattern:** We see patterns in colors or shapes as the basis for a composition in quilts, traditional Māori Tukutuku panels, and contemporary color field paintings.

**Rhythm:** This is the flow in a painting. Things have a rhythm but are not as rigid as a pattern.

Specific types of compositions result in a nice balance in a painting:

**Symmetrical:** A symmetrical painting is one that can be split down the middle and each side will basically be the same. Human beings naturally crave symmetry, and we seek it out in things like flowers and faces.

**Triangular:** Triangles are naturally balanced, and compositions with the triangle format are pretty reliable. A good example of a triangular composition is the *Mona Lisa*.

**Asymmetrical:** There can be beauty in a composition being off-balance with the majority of the objects existing on one side

of the canvas. Or maybe all of the shadows sit in one corner of the page. Edward Hopper's famous painting *Nighthawks* is an example of this. Japanese prints were often intentionally asymmetrical.

**Radial:** This balance is circular, with the focus in the center of the circles. Alma Thomas circle paintings are radial, as are some pre-Columbian Mexican art and Jasper Johns's target paintings.

**Rule of thirds:** Divide your painting into nine equal parts of three rows and three columns. If you create this grid on a piece of acetate and put it over some famous paintings, you would see that in many of them, the focal point lands squarely on one of the intersection points of the lines.

**Golden spiral or golden mean:** This is the pretentious mathematical ratio discussed earlier. This composition is complicated and mysterious, so we won't get into it here, but it is worth looking up.

## Exercise: Composition—Basic Landscape Painting

For this exercise, you will paint two simple landscapes. You need some sort of ground, like a field of grass or a beach. Let's add a tree. You can do the simplest version of a pine tree or palm tree. And then paint some sort of moon or sun. You can add a mountain peak in the background or a sailboat if you are doing an ocean scene. Of course, if you have painted before, feel free to fill your landscape with fences, cows, cars, or whatever.

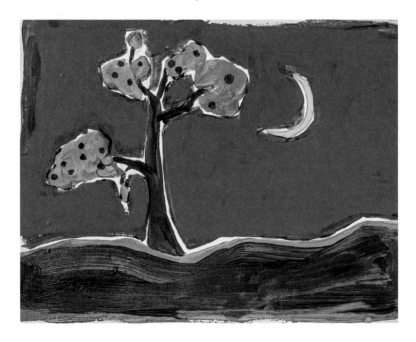

Filling the Space (Space & Composition)

Pick one of the types of compositions I just listed for your landscape painting. If you are doing an asymmetrical composition, you could paint three trees on one side of your painting and no trees on the other side. If you are doing radial, put a bright sun in the middle of the page with an ocean below it. For rule of thirds, you could first draw out the grid in pencil and then at one of those intersection points paint the sun or moon. Remember, as you paint, think about what color choices will make the most dynamic painting and help create a sense of space.

Now do that same scene again, but use one of the other composition types.

Renaissance artists came up with the idea of representing depth in an image by using lines that meet at one point on the horizon line, called the vanishing point. This technique is based on the fact that things get smaller the farther away they are from our eyes. Even if you are looking at a square box, the way our vision distorts things, the box will look larger on the side closer to you and smaller on the sides farther away from you.

First sketch a horizontal line across the page. The horizon line establishes the level where the viewer's eyes are and can go anywhere on the page. If it is higher on the page, it will make the viewer feel like they are traveling up, and lower will seem like traveling down. Make a small mark in the middle of your line that will be your vanishing point where all lines will merge and create a sense of depth and perspective. Then use a straightedge to draw lines that end at the vanishing point.

Now let's sketch out three buildings on each side of your paper and have them fit into those perspective lines you just drew. They will get gradually smaller until they reach the vanishing point and disappear. When you are finished sketching, you can go back with paint and build it into a scene.

Unless you are already advanced in drawing, use the most basic building shape, like you learned to draw in elementary school, for your purposes here.

*chapter five*

## LIGHT & SHADOW

The Padre's sign glowed red in the quiet night, marking the bar named after the priest who owned it. The sign was the only thing lighting up the railroad tracks that run past Padre's, through town and back out again, bringing the lonesome train whistle through Marfa, Texas, many times a day. As a result of spending so many nights eating burgers and fries at the bar, my five-year-old daughter, August, became a master at air hockey and foosball. That Christmas she asked Santa for a bag of quarters.

When August and I drove to Alpine, Texas, for breakfast burritos, we stopped on the way back at Jackassic Park, a roadside attraction where the donkeys had names like Dumb Ass, Lazy Ass, Jack Ass, and Candy Ass. The gift store sold pecan pralines and true crime books featuring the Texas Rangers. In a small and dark back room, you could sit on folding chairs and watch a grainy documentary about the Marfa Lights on an old VCR.

If you go a few miles outside of Marfa at sunset, you can sometimes spot the bright dots of the Marfa Lights far in the distance. People pilgrimage there at night, hoping for a glimpse of the phenomena that have been talked about for so many years.

Headlights on distant cars is the most boring explanation. I prefer more cosmic theories like the lights belonging to the glowing spirits of lost Apache chiefs or hovering UFOs. Intrigued by the film at Jackassic, we went to see for ourselves one night. August played with her dolls on the ground, I held our newborn, and Rob and I stood with both the skeptics and the believers, seeing nothing but stars embedded in a black sky.

NOT LONG AFTER THAT, I DROVE PAST THE MARFA LIGHTS ONE NIGHT ON MY WAY BACK FROM ALPINE WITH MY FRIEND BASHA. We had driven to Alpine to take a yoga class from a muscular, stocky man with a thick Texan drawl. "Namaste, y'all," he told us at the end of the class. I needed to distract myself. That morning my mom had called me from the hospital to let me know that a few hours earlier she had suffered what I later learned was a serious heart attack but what she tried to pass off at the time as a totally minor health ailment that had resulted in unnecessary hysteria from the medical staff. She framed it as the heart equivalent of a sprained ankle and insisted on calling me herself, her voice raspy, in order to prove to me just how fine she was.

Basha and I drove back to Marfa on the pitch-black road under a sky jammed and buzzing with stars and satellites. I had been on dark roads before in the north woods and on the long strip of I-90 between the

Black Hills and Sioux Falls, South Dakota, but almost losing my mom had reconfigured space and forever changed the scope of the sky and what spirits might populate it. The sky now hovered over a world that felt both extra desirable and totally ruthless. I now wondered if maybe the Marfa Lights might actually be the final messages transmitted to us from the people we love as they travel between this world and the next.

Light & Shadow

# Exercises: Light & Shadow

You begin this chapter already knowing quite a bit about light and shadow. You know that light gives us color, that light and shadow can create depth in a form, and that everything we see is the result of light hitting a surface. Now we'll explore how shadow and light do two additional important things in a painting: add drama and tension, and create a focal point.

I called this chapter "Light + Shadow" because it is a little sexier, but we're actually exploring something called value, which is the lightness or darkness of a color. White has the highest value, and black has the lowest.

Value is complicated. Not only is the range of lights and darks, of values, immense, but light and shadow can change a color, too. A yellow piece of paper in a shadow can have a darker value than a dark blue folder in the light because value doesn't just apply to black and white; colors have different values as well.

## What Light and Shadow Can Help You Do in a Painting

Here are three important ways that light and shadow can make a painting better.

> **Create a focal point:** Value shifts, or high shadow and light contrast, can lead your viewers' eyes to the thing you most want them to see.

**Infuse your painting with drama:** If you turn up the contrast, and put your whitest white next to your darkest dark, you create drama in your painting.

**Give a sense of depth:** When you put a bit of light on the edge of your vase and then paint a dark circle to show the shadows inside of the vase, it suddenly looks three-dimensional.

Different movements and time periods used lights and darks in different ways. Impressionist paintings have less drastic value shifts; the contrasts tend to be less or happen via a high contrast of colors, not light and dark. But paintings from the Renaissance often looked like they were lit by a professional cinematographer filming a movie like *Dr. Zhivago*. Those artists often used a technique called chiaroscuro, which relies on a lot of shadows and bits of brightness to heighten the intensity of an artwork. Chiaroscuro is what gives Caravaggio's work its amazing drama.

Some of my favorite olden-days painters are the most extreme in terms of how they exploit light and shadow. Francisco Goya, Édouard Manet, J. M. W. Turner, and Rembrandt all loved to paint extremely contrasted values, and they demonstrate that the more extreme your lights and darks, the more dramatic your painting will be.

This is one of art history's most famous paintings, Goya's *The Third of May 1808*.

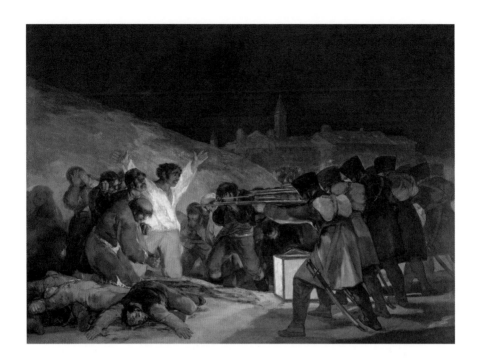

The painting is quite large, at eight feet by nine feet, and there is a great value difference between the hot, bright white of the man's shirt and the shadows shrouding the firing squad. The French gunmen recede into the back of the painting by growing darker, or lower in value, as they move away from the light source. This gives the painting depth and hides the identities of the men with guns, making them an anonymous force of violence. And by making the brightest spot on the painting the white shirt on the man about to lose his life, Goya illuminates the humanity of the victims of war.

Let's compare this painting to one Goya did a few years earlier, *The Second of May 1808*, also about the impact of war. The earlier work is

also a great painting, but it lacks the emotional impact, terror, and drama of the later version because the artist didn't employ the power of light and dark in the same way. The later painting makes us feel much more because we see a human being lit up and we connect the impact of war with this man.

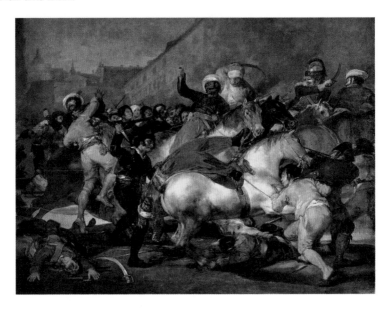

## Light Sources

Whether a face, an object, or a landscape, light gives us information about the thing we are looking at. Light reveals the texture of an object and tells us where a nose ends on a face or if we are about to step off the edge of a cliff. Different types of light offer more or less information. If you see my hand in a very dim light, you see a generic, shadowy shape of a hand. You will not see my veins, knuckles, or cuticles in need of a

manicure. If I turn on a bright light or move my hand closer to a light source, those details will appear.

Let's explore how various lights impact the object we are painting:

**Direct light:** This is the light from a reading lamp pointed on your book as you read in bed or the glaring sun on a beach ball. When painting an object in direct light, be sure your shadows are highly contrasted and distinct. In direct light, your darks are dark and your lights light, and there aren't a lot of grays separating a shadow from a highlight.

**Overcast:** The shadows on a cloudy day are soft, the light is diffused, and the edges of the shadows are weak.

**Reflected light:** When light hits an object, that object sends out a light of its own, a reflected light. We won't focus much on this here, but it is good to know that it exists.

**Backlit:** When an object has a strong light directly behind it, many of the details are removed because the backlit object exists in an extremely dark value range.

**Nocturnal:** There is an entire chapter on this later in the book, but for now, know that moonlight or light from a bonfire has an entirely different set of colors and impacts objects in a different way than an electric bulb does.

### *What to Know About Shadows*

Shadows eat away details.

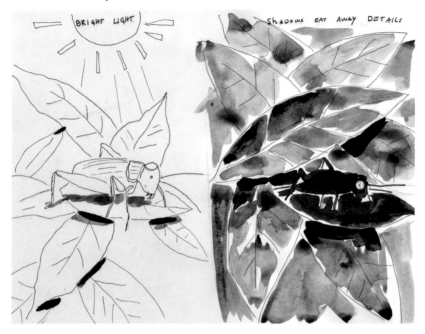

Although there are not really any black shadows in the real world, unlike a lot of people who would tell you not to use black in a shadow, I think black is okay to use if you want a stark, dramatic, or surreal shadow.

There are two main kinds of shadow:

- **Cast shadows:** The shadow your body makes on the sand when standing in the sun.

- **Form shadows:** The shadows on your object. The darkness on the underside of an apple, for example, or the shadow underneath your nose.

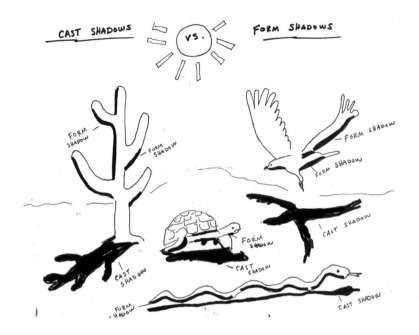

## Exercise: Notan of a Famous Painting

Great paintings are beautifully balanced.

There is a design concept from Japan called Notan that is an exploration of the balance between light and dark. Doing a Notan exercise of a painting can better help you determine if it is balanced. Notan is a way to map out the shadow and light in a painting by removing everything else—color, texture, etc.—so you only see where the darks and lights are. You could even do a quick Notan of your painting while in the middle of painting it, to ensure your composition has a strong balance of shadow and light.

Here is a Notan, a simplified map of shadow and light, of *The Third of May 1808.*

Let's look at your art book again. Pick a painting with a lot of light and dark contrast. Make your own Notan of that painting like the one I did for *The Third of May 1808*.

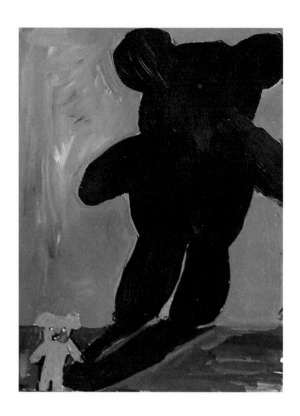

## Exercise: Menacing Teddy Bears

Light and shadow can create exaggerated scale, which can make a painting more dramatic. Let's play with the kind of lighting featured in classic horror or monster films, like how Godzilla is lit as he is attacking a village, or how a cinematographer lights a murderer barely visible in a dark alley.

Find some kind of small figure. You could use your child's toy dinosaur or an action hero, a Hummel figurine, or a teddy bear. Your goal is

to use light and shadow to paint the most menacing teddy bear in the history of the world.

You will need your figure, your art supplies, and a desktop lamp or flashlight.

You could backlight your object, which would create an evil silhouette of your object. We see this approach in superhero comic books when a villain stands in a doorway. You could turn out all the lights and put your phone on the ground below the figure so it looks like a horror movie killer emerging from the dark. Or you could do a super-strong direct light, put your object close to a white wall, and create a menacing and pronounced cast shadow on the wall.

Light your teddy bear in one of these ways and then paint that image, using as much contrast in light and shadow as you can. Try to paint a teddy bear or other figure that seems capable of terrible, evil things.

## Exercise: One Still Life, Two Different Lights

For this exercise, you will set up a basic still life of fruit in two different lighting situations. One will be a bright, directed light source that creates severe, well-defined shadows. The second lighting situation will use light from a window and the less defined shadows that result.

Build a small still life on your table. Because we want to make paintings that reflect us or matter to us, I suggest that you include one thing that really matters to you. Maybe it is your ear pods, a champagne glass, or your dog's favorite chew toy. Then, add two different fruits. Maybe an apple and a couple of cherries or a banana and a mango. Set them up on your table in a way that at least one of the objects is covering up part of the other object, so you can practice painting things that are overlapping. Three objects is a perfect number for this purpose.

First put a direct light near the still life. Do this by turning off your overhead light and putting a flashlight or reading lamp on your table. Sketch out what you see and keep your shapes simple. Carefully observe the way the shadows look, and re-create them in either many values of one color (you could do a range of blue, from dark to ultralight blue) or black and white, paying special attention to the contrasts between shadows. Notice how they overlap and focus on that emergence of one object and concealment of another object.

Next, move that same still life over to a window. Paint in the daytime when sunlight is available, and spend a minute noticing how the light and shadows and their contrasts differ from what you saw under the direct light. Paint that scene using a monochromatic color scheme.

*chapter six*

## WARM & COOL COLORS

People either love the South Dakota landscape or they hate it. Some people arrive, look around for anything other than a horizon line in sight, grab their phones, and calculate just how much more driving they face until they reach the border. Other people talk about their first visit to South Dakota with near reverence, not expecting how the flatness of the plains makes room for so much vastness of sky.

I love the landscape, where the sun rises from the land and hangs out in that massive sky for the day before dropping back to the earth hours later in a blaze of orange, purple, and pink.

Every July my extended family rents a hunting lodge in central South Dakota on the banks of the Missouri River, replete with a buffalo head over a stone fireplace and skeet shooting. A massive deck wraps around the lodge and serves as a viewing platform for the nightly light show that is a Missouri River sunset.

During the days, my cousin Scott pulls screaming kids down the river on giant inflatables with names like Big Mabel and G-Force. At night, the kids return to the lodge to overindulge in Shirley Temples, shoot pool, and get shooed away from the rattlesnake-infested brush.

One night we were having cocktails on the deck when a cold wind blasted around the corner off the lodge—this on a night when the temperature hovered at 90 degrees well past seven o'clock. Such a drastic weather shift is not a good sign in the Dakotas.

We hurried around the corner of the building to discover a massive bank of dark storm clouds. The air around the clouds was the ominous yellow-green color that anybody who grew up in the Dakotas recognizes as a tornado sky. While my cousins and I worried aloud if the lodge had a basement, my mom and dad and their generation casually dropped words like "funnel cloud." If they were witnessing the start of a tornado, those adults who spent their childhood on a prairie full of tornadoes didn't seem to care. In fact, some of them walked up the hill to get a better look at the storm.

I looked down at the river. That biblical sky had turned the Missouri River a magical silver color, like aluminum with a spit shine, and was lined with a startling edge of hot pink.

The Missouri is the geographic and philosophical dividing line of South Dakota and the place where eastern and western America collide. The town that hosts our reunion, Chamberlain, which you probably have heard of if you are a biker who goes to Sturgis for the motorcycle rally or a pheasant hunter, sits on the edge of the river.

Every summer when I was growing up, my girl cousins and I went to stay at my grandma's house in Chamberlain. She lived one block from

the edge of the river, and to prepare for our arrival, she tied pink bows to her tree and filled her deep freeze with Klondike bars and pizza rolls. We spent our days at the beach on the river's edge, where we escaped the Dakota heat and pretended to smoke the candy cigarettes we bought at Ben Franklin. A pack of city slickers with asymmetrical haircuts, we

dragged slimy driftwood logs from the beach and rode them around the swimming area.

I grew up believing that swimming in the Missouri was the ultimate swimming experience and never thought the superiority of rivers should be questioned until my Minnesota-born, lake-crazy husband told me that he grew up thinking that river swimming was a second-rate option to swimming in a lake.

My husband spent his summers at a cabin in a small resort town called Pequot Lakes, Minnesota, where the water tower has been painted to look like a giant fishing bob because, legend has it, of course, that Paul Bunyan rested his bobber there many years ago. Like every respectable resort town in Northern Minnesota, Pequot Lakes has its own weekend festival, Beanpole Days, when the town gathers to bury baked beans in six big kettles named Thor, Big Bertha, Ole, Sven, Lena, and Baby Olga.

The lake where Rob's cabin sits is stunning, as are all of the thousands of lakes in Northern Minnesota. A beautiful layer of fog covers it in the morning, and loons scoot over its surface at sunset. But there is no mystery in a lake, no shifting of its colors, no potential for being swept away to a new life on a fast-moving current. Lake beauty is far too static for me. If the trees that ring a lake are dark green in the morning, they will be dark green at night. Even on the stormiest, windiest days, a lake just kind of sits there looking pretty. Where is the mystery? Where is the potential for danger? Where is your always-changing sky, Minnesota? And what's with the algae?

I think I'm winning this river versus lake battle with our kids, who have spent enough time swimming against the Missouri's strong current and watching wide and technicolor sunsets, nothing any lake could produce, to know the truth. They have been on pontoons stocked with Twizzlers and

Cheetos lazily floating under hundred-year-old railroad bridges, passing by stops on the river with names like Carpenter Bluffs, Dude Ranch, and Red Rock, sounding like locations in a Louis L'Amour book. Once a kid has been strapped into a life jacket and experienced the powerful current of a river, any swim in a lake will leave them thinking, *That's all you got?*

The river is not too rowdy; there are usually more fishermen on it than Jet Skiers. The lack of boat traffic speaks volumes about the Missouri River's status as a neglected national treasure. Maybe it just isn't picturesque in the way that we traditionally prefer our American landscapes to be. It is not lined with thick patches of weeping willows or grassy picnic areas. Instead, there is resilient foliage and ragged bluffs that the sunlight shifts from gray to pink to green. The color of the water is just as temperamental. Is it brown, blue, or black? The color of a bruise or an old saddle? And sometimes the storm clouds make it a black crevice splitting up the prairie. I've been trying, and failing, for years to capture how that wide water distorts the Dakota sky that it reflects.

The Missouri is a study in warm and cool colors. The warmth of the sky and the coolness of the water. The sky sometimes glows a warm pink with the river a cool purple. Other times it all looks sinister, red and green, like the murkiest underwater growth of a swamp, teeming with stories of accidents and true crime. In my many painted versions of it, the river has been everything from dark brown to brilliant pink. Only sometimes do I paint the water blue.

AFTER DINNER AT THE LODGE, WE FILL THE DECK AND WATCH THE SUN DISAPPEAR ON THE OTHER SIDE OF THE RIVER. Our sky-viewing seems so old-fashioned, a quaint relic from the past like developing rosebush varieties or using a weather vane. It is goddamned poetic to do such a slow-paced thing in our digital age. Returning our focus to the sun's movements reminds me that we are alive now and that we will die someday. Some people find the reminder of the brevity and beauty of life staring at an ocean; my husband finds it on a lake's edge or in a thick grove of boreal trees; and some people, like me, find it watching the warm sun set over the cool Missouri.

## What Is the Difference Between Warm & Cool Colors?

We already know that cool colors move to the back of a painting as warm colors move forward. A warm yellow sun emerges from the clouds, and a cool blue sky appears far in the distance. We know that this recession

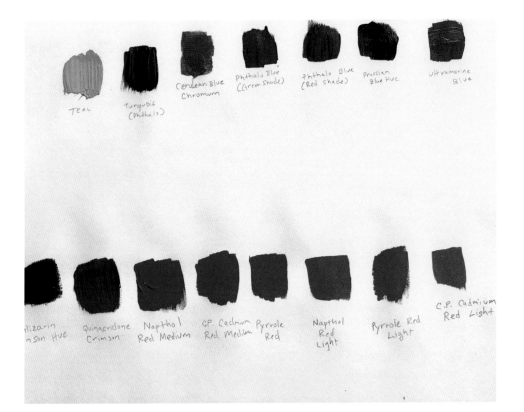

TEAL

TurquOis (Phthalo)

Cerulean Blue Chromium

Phthalo Blue (Green Shade)

Phthalo Blue (Red Shade)

Prussian Blue Hue

Ultramarine Blue

Alizarin Crimson Hue

Quinacridone Crimson

Napthol Red Medium

C.P. Cadmium Red Medium

Pyrrole Red

Napthol Red Light

Pyrrole Red Light

C.P. Cadmium Red Light

Warm & Cool Colors

and protrusion happens because of the length of each color's wave-lengths. But let's consider what this means for you as a painter. How do you exploit what you know about how your eyes see warm and cool colors to make your painting stronger?

Painters have to both think and feel when making a painting, so even as you are reacting to how you feel about certain colors, your brain should be considering warm versus cool. But your job becomes more difficult thanks to the fact that there are warm and cool versions of every color. All blues are not the same level of warmth; some blues are cooler than others because they have more green in them than red. It isn't easy to figure out which version of each color is warmer and which is cooler just by looking at the paint. Luckily, most paint companies have charts on their websites that show their color ranges and which of their shades are warm and which are cool. I keep a printout from my favorite brand of its paint's warm and cool chart in my tackle box so that when I need to figure out whether a color is warm or cool, I have a cheat sheet.

There is a second reason to know where the color you are using lies in the warm-to-cool spectrum: to make vibrant colors, you need to mix like with like. For example, if you are mixing a cool color like a shade of vio-let, you will make the brightest version of purple by mixing a cool red with cool blue. Mixing a warm red with a cool blue, on the other hand, results in a much muddier version of violet. To make the richest possible orange, which is a warm color, you want to mix a warm yellow like cad-mium yellow with a warm red like a cadmium red. If you mix a cool red like alizarin crimson with a warm yellow, you'll get a muddier, much less brilliant version of orange. That said, a muddy orange might be just what you need for a shadow on a squash or certain flesh colors. The ultimate

power that all of this color mixing experience and knowledge will give you is knowing how to mix the color you want and understand why you want it.

Let's look at a Paul Cézanne still life.

His orange and red fruit pop out more than the green apples do, giving his painting depth. Cézanne doubles down on the fruit coming forward by using cool, complementary colors in the background to accentuate even more the space between the foreground and the background.

## Exercise: Use Your Background Color to Create Extreme Depth

Let's return to your color wheel and create another still life with some fruit. This time, your goal is using certain background colors to push certain fruit forward as Cézanne did.

To build your fruit still life, you will need at least one cool-colored fruit, like a plum, a green apple, or a bunch of purple grapes, and warm-colored fruit, like oranges, cherries, or red apples. I suggest a couple, not just one, of both warm-colored and cool-colored fruit because as your skills improve, you should make your paintings a little more complicated. Let's elevate one of the pieces of fruit and maybe add a pitcher or a platter.

And for this exercise, let's try to both match the color of the fruits and shade them with light and shadow.

Consider your composition and how you will position your fruit with the mission of making this the deepest still life in the history of still lifes.

By now you know that if you want your fruit to pop, your warm-colored fruits (apples, oranges, and lemons) should be in the front and your cool fruits (grapes and limes) should be in the back. But what can you do in the background to help drive your warm fruit forward even more and create additional depth?

A dark background will emphasize the lighter colors of the fruit, as will a complementary color of whatever your warmest fruit is. If the fruit in the front of your still life is orange, a blue background will make that orange pop. Like this Cézanne still life.

You want to mix super-vibrant colors, so consult your warm-to-cool color chart from your paint supplier. If you are mixing an orange, use the warmest red you have with your warmest yellow. If you are mixing a cool green or a violet grape, use your coolest blues, reds, or yellows to get the richest possible color. Ultramarine blue and quinacridone red mix a nice purple.

## *Exercise: Warm and Cool Landscape*

Let's paint a sky, two trees, some grass, a sun, and a bird. How do you combine all those elements, and which colors should you choose, to make the bird and the sun pop and the sky recede?

Before you start, think again of your composition options: everything clustered in the center, tilted asymmetrical to one side, or rule of thirds? And because you want to make every painting memorable, is there a bird that symbolizes something to you? A flamingo means one thing while a hawk means quite another. Does a weeping willow have more meaning to you than an oak tree?

Warm & Cool Colors

*chapter seven*

## LEARNING TO OBSERVE

É douard Manet once said, "There is only one true thing: Instantly paint what you see."

As a painter, you must learn to paint what you actually see instead of what your preconception of a particular object is. You don't want to paint what your idea of a flower is; you want to paint what the flower in front of you actually looks like by observing and then capturing each specific petal and the bend of the stem.

University of Oslo psychology professor Stine Vogt, PhD, does research into whether or not artists see the world in a different way. Vogt asked nine psychology students and nine art students to view the same series of sixteen pictures while a camera and computer tracked how their eyes moved around the image. Vogt found that the artists' eyes looked around the entire picture, including the big parts of ocean or sky that most people would consider empty, while the nonartists focused only on the objects.

You can learn to turn off that part of your brain that sees the objects alone so you can go beyond just looking at the basic concept of something to notice the nuances. Artists train themselves to stop seeing a key as the generic key like any other key, and start looking for the identifying traits for that particular key, like a nick in the metal.

This idea of seeing like an artist led me to design a class for seniors around the idea of painting flowers in order to become better at observing the world.

THE CAREFULLY CURATED ACTIVITIES OF THE SENIOR CENTER TAKE PLACE IN A NONDESCRIPT BUILDING THAT RESEMBLES A DENTIST'S OFFICE MORE THAN IT DOES A SOCIAL HUB FOR SENIORS LIVING IN CROWN HEIGHTS, BROOKLYN. Every Monday I went there to teach painting to its patrons.

The center is painted the dull yellow of a municipal building basement and crammed with the objects required to take care of the mental, physical, and spiritual health of NYC citizens in their golden years—a menorah, a bingo set, a karaoke machine, and a defibrillator. The center smells like hospital food and bustles with activity. Only rarely does a lull take over when the women clutch their Styrofoam cups of weak tea and stop talking in Russian or Hebrew or Arabic or English to stare at the news.

The smaller, round tables in the center of the space are home to groups of women who demand the same spot each day, not unlike my grandma and her friends hoarded specific church pews. The tables by the

window are occupied by the fancier women who arrive in fur coats, full makeup, and jewelry and ignore the center's food in favor of their own delicacies spread out on paper towels. The seniors are mainly women, but a few older men are dropped off by relatives first thing in the morning to spend the day reading newspapers by the front door.

The seniors all seemed pretty heroic to me. I appreciated how they had not sacrificed companionship for comfort. They put on their faces, took unpredictable van rides, faced the trauma of crossing patches of ice, and accepted it all as the cost of human connection.

The center was founded by a tall, handsome rabbi with a warm smile, a thick white beard, and a sarcastic sense of humor. His hospitality was endless; he knew every senior's name and teased every employee. The center's second in command, Sasha, was the heart of the center, rushing around in three-inch heels, a blond beehive atop her head, and unbridled energy propelling her on.

"Get up! Get up! It is Zumba time! Come on, Mrs. Johnson, you aren't going to just sit here when you could be working on your biceps!" Sasha pushed them to eat a piece of fruit or drink some of the overly sweet kosher grape juice served in Dixie Cups.

"Who is painting today?" Sasha called out when I arrived. "Sara is here!"

We took a break in the middle of painting to follow along with the Zumba instructor Jonathan, whose enthusiasm and retro playlists got most of the women to do their seated exercises in their wigs, dress slacks, and knee-high stockings to the songs of Frank Sinatra, Michael Jackson, and Tony Orlando and Dawn.

My two hours at the center were intense. When I arrived, I quickly

got the paint, paper, and brushes out of the supply closet and filled many plastic cups with water from the always-occupied bathrooms. I ran around the room with Sasha, urging the seniors to find the energy to paint. Many of the seniors only spoke Russian or Hebrew, and I communicated through gestures or relied on English-speaking friends or caretakers to translate. I eventually learned a few Russian words for *beautiful, flower,* and *red,* which reminded me of a weaving teacher I had in Greece who, in order to deal with how terrible I was at weaving, learned English words like *bad, no,* and *stop.*

Teaching older people has some singular challenges, like issues with eyesight or hearing. Or arthritis, nerve damage, or poor muscle strength prevented them from gripping a paintbrush very well. And because of the language barrier, there would be no color theory or talk of perspective.

So my goal became twofold: to get the seniors comfortable with using paint and to encourage them to spend time engaging more closely with the world around them by observing it.

My decision to have them paint flowers had been a smart one. The simple shapes—lines, ovals, and circles—are not difficult to re-create.

The painters intently stared at the flowers and then stared at their paper. Flowers, paper. Flowers, paper. Even as they chatted with one another, they remained engrossed in their art. Some painters put on their bifocals so they wouldn't miss a detail. My focus on observing like an artist became an exercise in mindfulness.

Each Monday the seniors eagerly took the bouquets from my hands, excited to see what kinds of flowers I had brought. I was doing the classes as part of a fellowship that came with a budget for my supplies, so I could afford several different bouquets of flowers each week. When selecting the flowers, I looked for strong color combinations—one week a monochromatic selection of yellow carnations and roses, the next the boldest selection of reds and whites. Sometimes the women breathed deeply into the flowers and told me how a mother had grown that flower when they were growing up in Russia, Brooklyn, or St. Lucia.

VALENTINA IS A BEAUTIFUL RUSSIAN WOMAN WITH DYED RED HAIR AND A WARM CONFIDENCE. She held court at the table closest to the TV and the window, a power move that allowed Valentina and her cohort to enjoy both the sunlight and Fox News. She had never painted before but was a natural, and as her confidence grew, her marks became more determined. She began painting her flowers into scenes with skies, fences, and houses.

Mrs. Scheel was in her nineties and didn't usually paint with us. When she did, though, somebody had to dip the paintbrush into the paint for her. Then she slowly dabbed it on the paper, resulting in two beautiful paintings. One was a bright yellow flowerpot, perfectly lopsided, with a red flower dotting the top of a green leaf. In another painting, a wobbly green line led up to five dabs of red paint. On the bottom left, two globs of bright green paint made her illegible initials.

Aiza was the only person at the senior center wearing a hijab. She took up space, both physically and with her confident attitude. In her dynamic paintings, she outlined everything in thick, black lines, making the final product look like a stained-glass window.

Margaret fretted over her artwork but was able to see its beauty. Her thick, dark eyebrows met just above her nose, and her gray hair was pulled back tightly into a scrunchie. Looking at Margaret, you wouldn't know that she had been a professor and lived much of her life in the Middle East, because when you get old, it seems like your entire biography disappears, especially when you're an old woman.

Susie had immigrated from Africa, and one of her eyes looked to the side. She was the caretaker of a senior woman and so shy that I was

thrilled when she asked for paper and paint after a few Monday visits. She was methodical and focused, her lines elegant hatch marks. Her palette was muted, as if all her colors had been sitting in the sun for a while. She signed every painting by writing "SUSIE" in big, capital letters down the side.

The assistant rabbi slowly painted cryptic symbols. His paintings were made up of brightly colored shapes and reminded me of works by Joan Miró. Those shapes formed a secret language related to the Old Testament and rabbinical doctrines and took him several Mondays to complete. Much to Margaret's annoyance, the assistant rabbi offered the table biblical comparisons to the news scrolling across the TV.

Isabella, tall and striking with a blond cropped cut, was her own harshest critic. Her dark eyes squinted at me suspiciously when I told her how good her paintings were.

At the end of every class, we hung up their paintings to be admired. By the end of my three-month residency, the walls were covered in brightly colored flowers and we had an exhibit to celebrate how quickly they had learned to look at the world like artists.

## Exercise: Paint a Natural Object

There might not be any more beautiful art in the world than the great paintings of flowers. Dutch realists, Monet, Marc Chagall, folk artists, Hiroshige, William Johnson, Matisse, Roy Lichtenstein, Chris Ofili, Sulho Sipilä, Alex Katz, Takashi Murakami, and Mary Fedden all did epic flower paintings. You are going to try to do the same.

First, you need to get some flowers. Or, if you can't make it to a florist or Trader Joe's, grab a houseplant. A cactus will do nicely, too. Or a large seashell. Use something natural because things in nature are highly individualized and nuanced so nothing can be taken for granted, which makes them perfect for an observation exercise. Your focus will be on making decisions based on the specific color of the rose petal or the shape of a tulip stem, not what red color you think a rose should be or how a tulip stem is generally shaped.

This is the chapter where we really start building up your decision-making muscles that will allow you to continue painting on your own once you have finished this book.

Select one flower. Look at each individual petal on it, and notice how some are more elongated and some are chubbier. Note any small lines of color or bends. Much like specific details make a good short story, specific details make a beautiful observational painting.

How many petals are there? How does one petal differ from the petal next to it? Are there subtle shifts in color? What kind of shadows and light exist? Mix a few of the colors you see on your palette.

Sketch out your object with paint and a small brush. When you are happy with your composition, mix your paint and start painting. Repeatedly look at your flower/shell/leaf as you do so. You shouldn't be worried about creating a perfectly shaped flower or plant; this exercise is about observing details of the individual petals, the stem, the shadow one petal makes on the other.

Never spend more than ten seconds painting without looking back to your flower to confirm color, shape, and details. Paint the background either a color that makes your flower pop or one that will create a soothing, monochromatic painting.

## Exercise: Nonshiny Household Objects Still Life

Let's make a still life of simple, utilitarian household objects like bottles of shampoo or a pair of shoes, some pens, a couple of coffee mugs. Avoid anything shiny or reflective; those things are a separate kind of challenge we will explore later on.

Set up your objects so there are some interesting shadows, and maybe have things overlap each other in a few places. You could elevate something on a tissue box. Think of the scale of your objects, and how moving something tall next to something tiny looks. Consider using a reading lamp to get a more direct light source for more bold shadows.

Then look at each line or each form, and try to re-create it as best as you can. Again, the goal here is not a perfect painting or representation; it is to practice observing so you can train your eyes to look like an artist. Keep observing your objects as you go.

As Vincent van Gogh said, "Art demands constant observation."

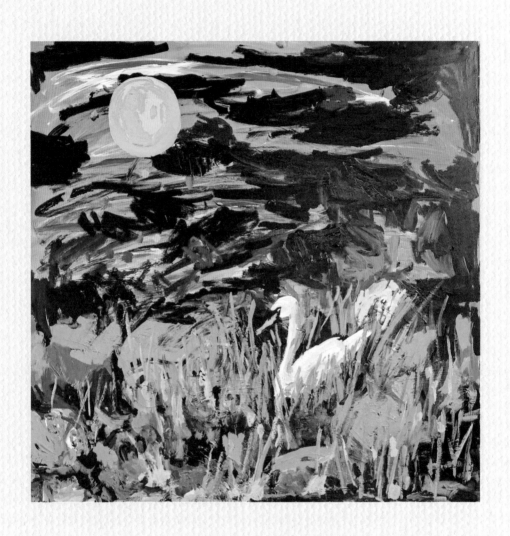

*chapter eight*

## PAINTING YOUR ARCADIA

The sky never looks the same way twice.
The wind is always picking up
Tossing down
the branches we gathered yesterday.

I n 2019, we tossed out all common sense and bought a fourteen-bedroom house in the Catskills. Built in the 1880s, the house is located in a small hamlet on the top of a mountain. In its early years, it was a boarding house for artists who traveled from New York City to paint the Hudson River area and all the flora and fauna in it. In the 1950s, Cornell University students prepared for hospitality careers by running it as a hotel and restaurant; we have the metal sign proclaiming it a Duncan Hines Road Guide pick as proof. In the 1960s and 1970s, the house became a commune, and older locals have hinted at the wild activities that went on inside.

We knew none of this backstory when we pulled up to the house after our Realtor called to tell us that a fixer-upper was about to go on the market.

As we drove up the incline of the circular driveway, we were taken aback by the haunted house appearance of the four-story building. It was something out of a Gothic novel, or somewhere Edward Gorey might live. We were met by the family who lived there and was busy carrying things to a Dumpster. They had recently lost their mother and wife, and their grief was palpable. Despite their grief, they were funny, charming, and gracious, and when they opened the front door, we saw elephants everywhere—elephant puppets, elephant ceramics, elephant tiles on the bathroom floor. Elephants are August's favorite animal and a talisman of good luck for our family.

"It's a sign," August and I whispered to each other.

They took us through all 6,000 square feet of that house, which was

filled with artifacts telling the story of the two people dedicated to art who had lived there the past fifty years.

Antique frames, paintings, blank canvases, stretchers, ceramics supplies, spinning wheels, kilns, pastels, paper, flat files, drawings, and art books filled the rooms. There was an old record player and a stack of jazz albums. The most emotional part of the tour was the mother's studio. She was a well-known ceramicist, and the wraparound porch served as her studio. Ceramic tools poked out of coffee cans, pottery wheels lined the room, and clay dust covered every surface. She had needed that large space to fit her larger-than-life ceramic statues, which reminded me of the Terracotta Army discovered in China, but more like creatures of mythology than war. I looked closely at the indentations, scratches, and marks in her work, the last vestiges of her hands. That's the thing about art; it contains traces of the artist. That is why my cousins and I love our grandma's paintings and why I love my mom's quilts and why the paintings you make will become the most cherished things that your family owns.

We decided to buy the house.

Most people thought we had lost our minds, but we are stupidly defiant and optimistic in regard to taking on seemingly hopeless projects. In fact, instead of wedding vows, Rob and I briefly considered vowing only one thing to each other: "I promise never to tell you 'Don't get your hopes up.'"

Besides, I'm married to a man who can do anything related to building, insulating, plumbing, landscaping, or roofing, and he can do it all for cheap using gifted stovetops, cabinets found at reuse-it stores, and craigslist purchases. If anybody could take on a project of that size with our nonexistent budget, it was Rob.

THE ARTISTS FROM THE CITY WHO FIRST STAYED AT OUR HOUSE IN THE 1890S AND EARLY 1900S WERE DRIVEN UPSTATE BY AN URGE TO PAINT THE HUDSON VALLEY'S SCENIC LANDSCAPES AND ALL THE CREATURES IN IT. Many of them stayed up there and built houses because in the Catskills they had found their *Arcadia*, a word in art and literature that means a landscape that is somebody's idea of Utopia.

Those early artists had teams of oxen drag their fancy furniture and pianos up the mountain so they could re-create their cultured city life up there in the wilderness. And they brought with them the fairly new invention of collapsible metal tubes, painting containers that replaced the messier animal bladders previously used by artists to take paint outside of the studio. Those seemingly unimportant objects changed the course of art. Painters were suddenly able to paint nature while sitting in nature. Without collapsible paint tubes, we wouldn't have Monet's gardens or any of the French Impressionists. And because the paints didn't dry out as quickly, paint companies invested in new paint colors, and those bright new colors brought with them the Fauvists, the Expressionists, modernism, and all the rest.

In the spirit of the house's history, the first thing I did was turn one of the old bedrooms, room number five, into a studio. I filled it with all the supplies the previous owners had generously left behind, like rolls of linen and canvas, stretcher bars, stretched canvases, and old brushes, and paint I had just purchased.

I filled an old yogurt container with water, looked out of the glorious old-fashioned windows with the metal grid, and started to paint the hawk that circled our property each day.

I'VE SINCE PAINTED A LOT OF THE ANIMALS THAT LIVE ON THAT MOUNTAIN AND HAVE FALLEN IN LOVE WITH ALL OF THEM. The prowling bears, the owls with their ominous wingspans and mournful calls in the night, the bats swooping out of the dark shadows, and the hummingbirds I have become obsessed with feeding. I love the chipmunks that scurry onto the porch to chase down crumbs from hot dog buns. My husband hates the fat-bottomed mole that lives under the house, whose very existence existentially tortures my dog, but I love him. He's a real character. The deer that bring the ticks with them? I love them, too.

I also paint the mountains when I can see them, after the morning fog that consumes the house like a cloud dissipates. And at night, we watch the surrounding mountain ranges turn Prussian blue as the sun sets through the trees. I like living on a slope on the side of a mountain, surrounded by the kinds of animals that live clinging to the tilted earth and trees hearty enough to survive the winds. That wind blasts against our house many nights, seeming to actually shake the frame, playing its cinematic sounds that make me want to write a Gothic novel about vampires, and I am reminded that some things like that wind will never disappear from the earth, no matter what stupid things we humans do.

Somehow I have added a second Arcadia to my original Utopia on the prairie. This one is windy, too, but whereas my life on the prairie was a lot about me looking up at the sky, this Arcadia has me feeling deep affection for the view down in the valley.

PAINTING CAN SAVE YOUR LIFE

*{140}*

Trees: Before I paint a tree, I mix many different shades of green, ranging from bright green with lots of yellow, to dark green mixed with a bit of red. Leaves painted in a diverse combination of cool and warm colors create the sensation that some leaves are receding and some are closer to you. And mixing lighter colors with darker ones mimics how sunlight brightens up some leaves while creating shadows on others. Leave spaces in the green of the leaves to allow bits of light and blue sky to poke through here and there.

If you are painting a bunch of trees, remember that the trees in the front will have more details and be lighter, and the trees in the back will be more abstract and darker. For the trunks, you can either become extremely detailed or make a strong, dark mark that mimics the strong shape of a tree.

Grass: We tend to forget how many types of grass there are. There is suburban, fancy, landscaped grass. There is long, windswept prairie grass. There is the feral grass of the neighbor who never mows or the grass next to a highway full of both trash and wildflowers. There is swamp grass with the occasional alligator nose popping out of it. And there are just as many ways to paint grass as there are types. You could do a graphic block of solid green or paint a green background and then dab a bunch of individual blades over it. You could load your brush with paint and do a moody, abstract field of lush marks. I like to paint the back of my field of grass first with a darker, cooler color before adding individual blades.

You don't need to draw every blade of grass. Our eyes and brains are pretty amazing at filling in the blanks.

Clouds: I first apply the darkest grays or blue grays on my clouds and then paint lighter shades of gray and white on top. Clouds are often darker on the bottom with the whitest highlights on the top of the cloud.

No cloud is alike, so observation is crucial to creating a lifelike cloud.

Water: The main thing to think about when painting water is that it is a reflective surface and you must be aware of how the things that are located next to or on the water, like a red boat on a pond, or flying above it, like a crane flying over a lake, will be reflected on its surface.

When painting rivers, oceans, or lakes, you have many colors to play with. Of course, water can be painted blue, but it can also be gray, brown, black, or green.

When painting large bodies of water, I create a couple of versions of blue, maybe one warmer, one cooler, and in a few values of light and dark. Having a dark purple or forest green on hand doesn't hurt either.

Where the water is more shallow, you will need to paint the color of the surface under it. So if you are painting sand in a shallow part of the ocean, your water might be more tan than blue.

Deeper water is generally darker. Water away from the shore will probably have a more still surface, while water closer to shore is generally going to have a little more activity. For an ocean, consider using quick, powerful brush strokes to mimic the motion of the ocean and the force required to push the waves onto the beach and then pull them back out to sea. Look at paintings by J. M. W. Turner to see how it's done.

Animals: Some of my favorite paintings are of animals, and animals are one of my favorite things to paint.

PAINTING CAN SAVE YOUR LIFE

There are lots of paintings of animals to look at for inspiration.

Gladys Mgudlandlu painted bird moms and dads bringing worms back to nests full of hungry chicks, an image so engaging, it might as well be a portrait of a human family. Her cattle in arbitrary colors are surrounded by an orange glow. Her otherworldly animals were often painted from an aerial perspective, as if Mgudlandlu was flying over them in the sky.

Winslow Homer's realistic paintings capture animals at the moment

they are being shot by a hunter, on the edge of death, or hunting their own prey. The animals become poetic images of the fleeting nature of life, and their beauty goes beyond realism.

The Lakota painter Oscar Howe painted eagles and horses as diamonds and slabs of color and made them celebrations of movement.

Just as he simplified everything to its most basic shape, Milton Avery made an owl out of a stamp of pink and two swans out of two white marks on a dark blue square. Rose Wylie paints massive simplified butterflies, dogs, and horses that take on an almost godlike status as they fill up entire canvases.

When I am painting an animal, I first capture its silhouette. Next I add the areas of light and shadow. On top of those layers, I add more detailed bits of information, like fuzz on the ears of a bobcat, long eyelashes on a horse, or a wet black nose on a dog.

## How Do You Paint a Landscape?

Landscape painting has a long history. Ancient Romans and Greeks painted landscapes on their walls, and landscapes played a starring role in Chinese and Japanese early work. But for a long time in the West, it was uncool to paint landscapes. It was considered an inferior subject matter and only acceptable to do if you were telling a Bible story. Job or Moses had to be sitting in a beautiful landscape, or there was no reason to paint one.

After the Dutch made landscapes cool again in the 1700s, American painters in particular really took to it, probably because in their land grab, our founders had claimed and colonized one of the most majestic collections of scenery in the world.

Some great American landscape painters worth exploring include Charles Burchfield, who exaggerated nature to the point that his worlds were extraterrestrial realms of atomic sunbursts and radioactive trees; the painters of the Hudson River School; Martin Jonson Meade; Barkley L. Hendricks; Richard Diebenkorn; Grandma Moses; Leonora Harrington; and Marsden Hartley. And today we have contemporary masters of American landscape, some of whom put their landscapes behind lots of people, like Lois Dodd, Kerry James Marshall, Celeste Dupuy-Spencer, Jules de Balincourt, Rackstraw Downes, Pat de Groot, Matthew Wong, and Kay WalkingStick.

# Exercise: Paint Your Arcadia

What is your Arcadia? Is your utopian landscape a pastoral scene in the country or a dynamic cityscape? It could be a mountain, or it could be the sea. If you don't live in your Arcadia, use a photograph of that place as your guide. To those of you lucky enough to live in your most important place, set up outside or look out a window.

Landscapes can be intimidating, but a few tricks can make them easier.

## LANDSCAPE PAINTING HACKS:

- Larger, more-detailed objects in the front; smaller, less-detailed objects in the back: This is the way your eye actually sees the world, and painting like this helps re-create that optical depth in a painting.

- Foreground focus: A cow or a flower bush in the front of your painting helps create depth. This also makes the viewer feel like they are in the scene.

- Lighter to darker, darker to lighter: This use of value creates a sense of depth and better differentiates the foreground from the background.

- Insert an S-curve or path: This helps the viewer travel through the painting.

- Add overlapping diagonals: You don't have to capture the scene exactly as it is. You can add a diagonal road or hill where there isn't one to add more depth.

Or, do like painter George Morrison did, and break all the landscape rules.

**THE FIRST THING I DO WHEN PAINTING A LANDSCAPE IS MAP IT OUT INTO A COUPLE OF SIMPLE CHUNKS OF COLOR.** If I was doing an oceanscape, I might have a chunk of blue for the sky, a different color chunk of blue for the ocean, and a block of tan for the beach. If it is a cityscape, I'd map out the blocks and shapes of the buildings and how those gray or black rectangle shapes break up the negative space of the sky into chunks of blue. Do this with your landscape, too.

Next, using a small brush, sketch out more details of your composition over those chunks. Consider what would happen to your painting with an object in the foreground or a road traveling far into the distance.

How can you utilize color in a smart way? If this is a place with strong memories, what colors does it conjure up in your mind? When I paint the prairie, I often exaggerate the earth into long expanses of sienna. When I paint the sky there, I use a ton of blues, greens, and purples to

demonstrate how it is a mood ring of sorts, never the same color on any given day.

Now it's time to mix your paint and start painting. When you have covered your page or canvas, consider what details you need to separate your Arcadia from another ocean shore, another swamp, another city.

## Exercise: Change the Season

If you painted your Arcadia in the summer, now paint that same place in the winter. Or vice versa. You don't have to capture every mound of snow or leaf on a tree; a patch of white will read as snow, and a dab of orange on a dark tree easily reads as a cluster of autumn leaves.

## Exercise: Paint a Moment in Nature That Wowed You

For this exercise, I might paint the time I was with our friends Jill and Brian and their kids and we were all stuck in our car at a historical farm that we had traveled to in order to see the baby farm animals. As the scariest thunderstorm raged overhead, I waited for the giant tree we were parked under to crash on top of our car. Or I might paint the dead bat we recently saw on the ground of a cemetery. Or maybe I would paint the monarchs that circled the milkweed in our backyard all summer.

If you don't have any amazing personal outdoor moments, you could definitely find one on the internet. I encounter at least one amazing wildlife video almost every day.

## Exercise: Paint a Predator-Versus-Prey Moment

Capture a scene from a wildlife movie, a pelican catching a fish, or the wildebeest outpacing the lion. This is more about getting the tension of the moment than about perfectly representing any of these animals.

*chapter nine*

## PAINTING THE FIGURE

O n my first day of my freshman year, I entered the disheveled art building at the University of Minnesota and encountered a round bench filled with emaciated art students staring back at me. The boys had hair in their eyes and were surrounded by skateboards, cans of spray paint, and bags of loose tobacco. The girls wore homemade dresses constructed of hemp and vintage baby doll dresses. Or at least that's how I remember it.

I offered them my biggest smile, the one that had helped me earn a slot on the Lincoln High School homecoming court. When that was met with scorn and disinterest, I sat down on the bench across the room and wondered what was it about me that turned them off. Was it my massive dyed blond hair? The mall outfit? I hadn't said a word yet, so it couldn't have been my vocal fry.

Those art students were obviously defiant rulebreakers, capable of both fashion extremes and criminal activities, whereas I was the poster

child for mainstream. I assumed that their boldness and deviance resulted in profound art. Which meant, I realized, that a scared, vacuous girl like me would only create timid and insipid work.

My first year of college I was usually on my own in the art building. If art parties were happening, I wasn't invited. No matter; with my friends from the dorm, I took advantage of the rotating parties in the Greek system, where any girl could score free beer if she was willing to put up with beer goggle jokes and playlists full of Meatloaf ballads.

My isolation in the art building is why it was so remarkable when Brett Balzac asked me to meet for coffee. Not only was Brett one of the moodiest of the art students, he was a good four years older than the rest of us. His standing as a true artist had been cemented when our Introduction to Drawing teacher asked us to draw something on our body and, while the rest of us bashfully removed our shoes and socks and began drawing our toes, Brett headed to the men's bathroom, stripped down, and drew his naked torso in the bathroom mirror. Getting asked to coffee by Brett had the potential to be a real game changer.

That Saturday I ventured into Dinkytown, the Bohemian heart of the university where Bob Dylan hung out in the 1960s and where 1990s university girls without bras and boys without deodorant congregated to be pretentious as a group. Brett strolled into Espresso Royale. He had long, black hair and weighed a good forty pounds below what was medically advisable. We got our coffees and sat down, my mind whirling with the possibility of how Bohemian I could become with this new friend. I would soon write poetry and refuse to go home for politically incorrect holidays.

Brett wasted no time in letting me know why he had actually asked me to meet him.

"Would you like to pose nude for me?" he asked in his fake French accent.

Brett Balzac didn't think I had the potential to be interesting; he thought my breasts had the potential to be interesting and wanted to judge for himself. I wanted a friend in art school, but not that bad. I refused his offer with the apologetic mania that only an eighteen-year-old girl from the Midwest in 1989, or Diane Keaton, could muster.

"Oh wow! Thanks, but I guess not? Sorry! That is so nice of you to want to paint me and everything, but I better not."

Sitting anywhere in the broad daylight without my clothes on was not going to happen, and Brett didn't seem to want to hang out with me fully clothed, so we never did become friends. But I thought a lot about his desire to paint me, a woman, nude. What is with men always wanting to paint naked women when they could paint a naked man, a dog, or a bunch of grapes?

Maybe it all started with whoever painted all those frescoes of naked women in Pompeii—probably a man. There are naked women all over Eastern and Western antiquity. There are about a hundred painted versions of the very naked Susanna from the Bible. Manet dropped a very casually naked model into a bunch of fully suited men in his *Luncheon on the Grass*.

Pierre Bonnard got famous painting naked women, usually in their baths or drying off after taking a bath. Look at too much art history, most of it painted by men, and you would think that all women walk the planet totally naked, or are just about to be naked, or that we never leave the bath.

In college I sought out female painters to see how they approached the human body, but there were not many women featured in our art history books, and even fewer of those women were painting the human figure. Eventually, I found three painters to inspire my figure work: Susan Rothenberg, Faith Ringgold, and Alice Neel.

Rothenberg first became famous for painting horses, but it was the human bodies she painted, cut apart and dismembered, with a decapitated head floating here, a forearm hovering there, that impacted me. She painted emotionally raw paintings with energetic marks, the kind I wanted to make.

Ringgold is most famous for her textile art, but the first time I saw her painting *Die*, a massive mural depicting blood and violence and the

struggle related to race relations in America in 1967, it shifted many things for me. It was proof that a woman could paint a massive, difficult-to-look-at artwork about a massive thing like violence just as well as Picasso did. Her human figures were flat, their shadows removed, and in various stages of flight or fight. Ringgold's work made me want to become a better technical artist so I could produce a work as complicated and perfect and epic someday.

Neel's subjects were usually clothed, and that clothing offered clues about her subject's life, state of mind, and place in society. Neel did a painting of herself nude at eighty years old, paintbrush in hand, the sagging, redistributed body of an old woman sinking into a striped chair. She later said her flushed cheeks in the self-portrait were proof that making that painting had not been easy on her.

And even more contemporary female painters have subverted traditional figure painting further by painting looming, bold, fat, emaciated women clearly made of actual female flesh. Paula Rego's highly stylized and often costumed women have a punk attitude and aggressive stances you don't normally see depicted in a painting of a lady. The British artist Tracey Emin lined her figures with jagged, charged lines. I walked into a Chelsea gallery years ago to be knocked flat by one of Jenny Saville's canvases on the wall. The painting was nothing but pale skin and ruddy flesh, darker in some parts, rashy in others, the figure jammed into the four corners of the canvas like Alice in Wonderland growing larger. Saville had painted the woman from a very low perspective, which made her large breasts and thighs look even more substantial. Saville took the very things women are supposed to hate about our bodies—curves and flesh—and highlighted them as the things that make us remarkable.

## Exercises: Human Figures

Not unlike landscape painting, there was a period when figurative art was a little out of fashion because representative work was considered uncool as artists pivoted to making abstract art. But when people like Bob Thompson, María Izquierdo, Paula Rego, Barkley Hendricks, Fernando Botero, and Robert Longo are out there revolutionizing art featuring human bodies, art that is too good to ignore, painting a person will never really go out of style. And today we have figurative innovators like Dana Schutz, Salman Toor, Danielle McKinney, Lisa Yuskavage, Nicole Eisenman, Mira Dancy, Aliza Nisenbaum Alejandra, and countless others taking figurative art to its next, amazing place.

But unless their work is intended to be completely disproportionate or exaggerated, even those artists must occasionally remind themselves of the basics of figure drawing that they learned when first attempting to make a human figure that resembles a human figure.

### Figure Tricks & Tips

Here are some of my favorite tricks and tips in my painting arsenal, the ones that I repeatedly turn to in order to ensure that the body I paint ends up looking like it belongs to an actual human being.

Proportion: Accurate proportions are key to painting a good figure because, having looked at human bodies our entire life, we innately know when proportions are off. Look at some *Game of Thrones* or *Friends* fan art, and if it is bad, I guarantee that it is bad because the arms are too short, the shoulders too wide, or the femurs too long. Of course, your first job is always to carefully observe the figure you are drawing, but

there are some measurement tricks and hacks you can use after you have sketched out your figure, just to confirm it is proportionate.

Key proportions measurements (for adults) for you to know:

- Our bodies are about as tall as about seven and a half of our heads.
- From the top of the head to the belly button is about three heads.
- The belly button lines up with the elbows.
- Our chest is about two full heads across.
- Our arms are three and a half heads.
- Legs are about four heads.
- Our fingertips usually land mid-thigh.
- From our knee to our foot is two heads.

A good way to test this for yourself is to pick an image of a person you would like to paint, print out the image, and map out these measurements. Then, when you go to draw this figure on your paper or canvas, you could actually sketch out the figure and try to break down the proportions in the same way before you start painting.

Alignment: Bad alignment and an inaccurate curvature of the spine also look strange. Spines are not straight, and their curvatures can be subtle or surprising. If one person is hopeless and tired, and another person is brimming with hope, they will have two different kinds of alignments. Does the person you want to paint have a recognizable stance? Print out some examples of your figure, and with one line, trace their alignment and curvature on the paper. Then draw that same curve on your figure and be sure that the two curvatures are in sync.

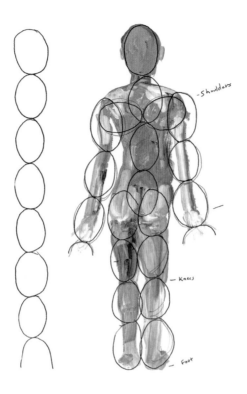

Body angles: Another thing to focus on is how an arm or a knee bends. Again, you could draw the angles on your reference image and then repeat those same angles as you sketch out your figure on your canvas.

Light and shadow: Light and shadow are what makes it obvious that human anatomy exists under our skin. So be sure you have shadows proving that there are collarbones and kneecaps emerging and eye sockets receding.

## Painting Faces

I'm not sure which part of a human being is more of a challenge to paint, the body or the face.

Anytime I have tried to paint my own face, I have found it an almost impossible task. I can't break it down objectively into shapes and shadows, light and slopes as any good painter should. I only see signs of the hot dish of my ancestry and the worst physical traits on my family tree.

I am not such a harsh critic when I'm painting other people. In fact, staring at the faces of people I love in order to paint them seems to make me love them even more.

One of my favorite paintings I've ever done is a portrait of my daughter, August, as a ten-year-old. I love the portrait because it captures her

energy, which is a lot. We once had a playdate with a little girl much more bookish and serene than August is. At the end, the other mother said, "Well, that's the first time I've met a five-year-old and thought, *That girl is going to grow up to be the last person to leave every party.*"

In the painting, August seems to be leaning forward, as if to find her way out of the frame, her energy far too much for such a two-dimensional depiction.

My niece Tessa is a kind-hearted and artistic person. She laughs a lot and is guaranteed to fall into a pond if she goes near one. Her high level of sensitivity has made her a talented artist and given her a gravitational pull toward children. I painted her holding my cousin's newborn. In the portrait, you can see her natural ease with babies and the mischief in her eyes.

My son, West, has a way with animals and is some sort of child prodigy when it comes to spotting lizards and frogs attempting to camouflage themselves. I painted him deeply engrossed in a skink, his hair in his eyes as always.

Whether you love the person or not, human faces are difficult to paint. The famed portraitist John Singer Sargent captured the difficulty of painting a *good* portrait by saying, "A portrait is a painting with something wrong with the mouth." Your local thrift store probably has several fairly awkward portraits for sale that prove this statement. But when done well, there is nothing more compelling than a portrait of another human being.

The difficulty of portrait painting is why it is my most interesting class to teach. People are timid or anxious about getting started. I don't blame them; faces are tricky. What we think the proportions of the face are usually isn't correct. In the case of painting a self-portrait, you have the extra burden of peering into your own face and pulling out your own humanity, which requires honesty about what is really looking back at you.

Historically, portraits in Western art were often dark and moody and portrayed some grim-looking people. Or they existed to make heroes out of leaders and aristocrats. But over time, portraits became more playful or realistic. Portraits have helped many artists define their style. An Ernest Kirchner portrait glows with startling greens and pinks, has dark circles under its eyes, and a cigarette clamped into a stern mouth. Amedeo Modigliani's portraits of women with long necks and elongated faces made him famous. Fujishima Takeji adopted a French nouveau approach and combined an ethereal Renoiresque paint application with Japanese textiles. Picasso took the human face and rearranged all the features, and a Charles White portrait goes beyond just offering us the face of a person—we get their personal experience, too.

In the 1990s and 2000s, women advanced portraiture. Chantal Joffe, Elizabeth Peyton, and Karen Kilimnik played with androgyny and the idealized American woman. In the 2010s, a new vanguard of Black portrait painters like Amy Sherald, Jordan Casteel, and Kehinde Wiley transformed the painting of portraits yet again.

As you start painting portraits, there are some tricks to know. Like the human body, a person's face has set proportions that can be measured and hacked.

Measurement tricks for the average face:

- The eyes and ears are in the middle of the skull, not in the top third, as many people draw them.

- The width of a face is equal to five eyes lined up across it.

- From the chin to the lower lip is one eye width.

- A somewhat rudimentary measurement hack can be made when you put your thumb against the side of your pointer finger. The distance from the top of the thumb to the top of the pointer finger can roughly equal the height of the ear, the space between the pupils, the space between the eyebrows and the hairline, and the bottom of the nose to the bottom of the chin.

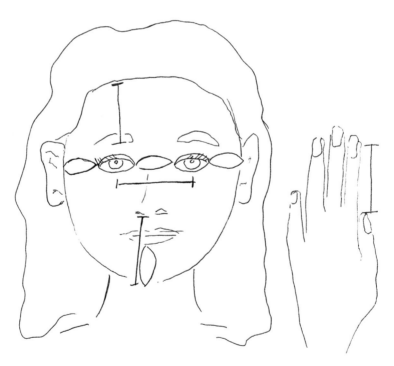

- We should never see the entire eye. The lid always covers part of the eye.

- When you're painting an eye or nose, remember that there is a three-dimensional structure under the skin. The nose is not a triangle; it is a pyramid. Be sure to capture the light and shadows those forms create.

## Things to Think About When Painting Skin

- A wide range of skin tones can exist on one person. The skin that covers the biggest veins in my hand is almost blue, and the shadows on my neck look dark gray when I'm in a dark room.

- Skin offers a lot of clues about the person you are painting, and revealing the person is what you are here to do. People who drink a lot of wine can have redness around the nostrils. Little kids often have redness around their nose or eyes from being congested. A stressed-out young mom might have dark circles under her eyes.

- Different light sources create different skin tones. My skin is a different color in a fancy restaurant with candlelit tables than it is on a tennis court in broad daylight. When standing in a forest where the sun is being filtered through thousands of leaves, my skin has a pattern of light and dark tones.

- If I am standing next to a red house, my skin will reflect some of that red because my skin is a reflective surface. If I was painting a person standing next to a school bus, I would put some yellow in their skin tone.

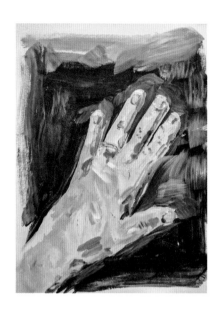

## Exercise: Match Your Skin Tone(s)

Spend a moment looking at the various colors on your hand. On my hand, the brightest bit of skin tone, the highlight, is the tip of my pinky. The darkest bits are the parts between my fingers and on the far side of my hand that is away from the light source. I see a lot of yellow and green tones in my fair skin. If you have darker skin, you might notice more earth tones, oranges, and maybe dark blue undertones or a bit of purple.

Put equal amounts of red, yellow, and blue on your palette, and cut out a bunch of small pieces of white scrap paper to use as swatches. Mix an equal amount of the three colors, and play around with mixing that base with white or yellow to lighten it, or red or blue to darken it, until you are close to the general color on the back of your hand. Put a little

paint on a swatch, and hold it up to your hand. Chances are that you won't get your color right the first time, so keep trying different swatches until you have a variety of paint colors somewhat in sync with your skin. Darken with red or blue or one of the siennas to match the shadows between your fingers.

Keep up this matchmaking until you have four or five colors that match the various tones on your hand. Sketch out your composition, and get started.

You could do this color swatch experiment with the flesh tones of the other people in your house and create a group portrait of your family or friends as a series of hands.

## Exercise: Paint a Portrait of Somebody Else

You could paint your aunt, Jane Goodall, Snoop Dogg, a character from *The Office*, an ancestor, a hero, or a villain.

Painting from life is always the dream, but for this first attempt, I suggest you paint a face from a photo so you can take your time, measure the spaces between your features, and hold up color swatches to the photograph.

Step one: Map out the features of the face in pencil:

- Draw an oval and then draw a vertical line through the entire oval.
- Sketch in the eyes. Remember, they are about in the exact middle of the head.

- Add the ears, which are parallel to the eyes.

- Sketch in the mouth. It is my opinion that a less overdone mouth always looks better. A few lines defining the shape and size of the lips is good enough. Then, when you start applying paint, you can use a few gestural marks to show the lips. When people try to perfectly re-create lips, it often looks a little cartoonish.

- Be light-handed with the nose as well. Look at an Alex Katz portrait for guidance; he often just gives us one line for the bridge and two marks for the nostrils.

Once you have the features of your face sketched out, see if anything looks off-kilter. If the proportions don't look right, get out a piece of paper and check the measurement hacks I provided earlier.

When you are happy with the proportions, mix your paint. Create four or five different colors that reflect the various skin tones, making sure that the values in those colors reflect the lights and darks on your face, from the highlights on the top of your cheeks to the darkness under your nose and in the eyelid.

A few general notes:

Hair: Your hair will be darker underneath and in the back where light can't hit it. Paint the darker bits of hair first and then paint the lighter sections over that. This will help to create the sense that your hair has depth. The brightest bit will be on top or on one side, depending on where your light source is. I first paint chunks of hair rather than strands. Then I go back and add a few strands to make it look real.

Eyes and teeth: The things we consider to be white, like the "whites"

of the eyes and teeth, are proven not to be white at all by holding a piece of white paper next to them. Super-light yellow or maybe a light yellowish gray is a better option than white.

Eyebrows: First establish the general shape and color of the eyebrows and then go back with a tiny brush to paint a few strands here and there to give the sense of hair. Don't fill in every piece of hair unless perfect realism is your goal.

## Exercise: Paint Yourself

This second portrait will be more difficult than the first. It is one thing to objectively see another person's face as a series of planes, protrusions, and indentations. It is quite another to use such an objective lens on yourself. But try to look at your face as a collection of shapes, colors, and shadows. In the process of looking at our own faces with objectivity and not disappointment or criticism, this exercise can become a lesson in finding the beauty in your own face.

## Exercise: Paint a Person

If you can get somebody to take their clothes off for you, great, go for it! Otherwise, ask a friend to come over and sit fully clothed, or find an image in a book. Maybe you want to paint a Greek statue or a Brassaï photograph of a woman sitting on a bench in Paris. Great figure paintings capture the spirit of a person, so look for clues about the subject in their clothes, pose, and alignment.

Then follow these steps:

> **1.** Sketch out the alignment, or curvature, of the figure in pencil or a bit of paint using your smallest brush.

**2.** With a focus on the proportions, on top of that curvature, map out the general shape of the head, torso, and limbs. If something looks off, use a piece of paper to measure the proportions the way I described earlier.

**3.** Sketch in key features like eyes, mouth, feet, and hands.

**4.** Be sure the bend of the arm you are drawing is the same angle as the bend of the arm on your subject.

**5.** Prepare your paint, and use some of the darkest color you are going to use to establish the shadows on your body, like the space between the legs, the shadow on the neck, or under the breast.

**6.** Paint your flesh tones on the hands, arms, legs, feet, and anywhere else on the body where it is not clothed.

**7.** When you are happy with the general shape and values of your figure, start adding details like clothing, hair, and eyeglasses.

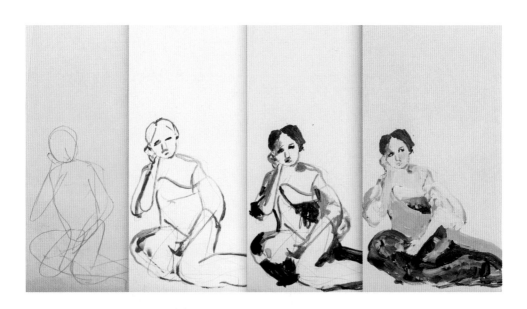

## Exercise: Paint from Your Family Tree

Look through old family photos for an interesting image of your young grandmother in a black-and-white photo or your mom in college. Sketch out on your canvas a line that mimics their alignment in the photo; map out their head, torso, and limbs; and then sketch in the angles of their elbows and knees. When you are happy with the body, add telling details, like their clothes or a cigarette in their hand—things that tell us about them. Consider playing with the facts before you. Do you want to re-create the exact color in their dress or try to use different colors in order to make the color relationships more impactful and have more depth?

## Exercise: Paint People Interacting

In a photo album or a book, find a picture that has two or three people interacting. Painting multiple figures can be challenging. It is my experience that I get one figure just right but then the proportion of the other is terrible.

Sketch out your interacting figures before you paint. Do you want the two figures on one side for an asymmetrical composition? How could you alter the interaction of the two figures to create more tension than what exists in the photograph? What details could you add to tell a story? If one figure is holding cooking tongs and the other a hamburger, that is a different story than if one has a sword and the other has a shield.

Painting the Figure
{173}

*chapter ten*

## TELLING A STORY

That winter the main street of Marfa, Texas, was so empty and dusty, it felt like everybody was hiding away from a looming gunfight. Actual tumbleweeds sometimes blew across the road. And it wasn't unusual to have to stop our truck to let a pack of wild turkeys pass.

It was the holiday season of 2011, and my husband had been awarded a residency at the Chinati Foundation in Marfa. My daughter was five and my son four months, and we were housed in an apartment inside the museum, which the artist Donald Judd had built to permanently house the large-scale artworks that he and his close friends created.

Judd's masterpiece, the polished aluminum boxes of *100 untitled works in mill aluminum*, resides in a massive artillery shed directly across from the kitchen window of our Marfa apartment. I looked at those 100 boxes day and night as I performed the kitchen duties associated with having two kids. As the sun moved across the West Texas sky, it made

sure that the surfaces of those 100 boxes hit every note on the spectrum between warm and cool, from the stark, steel gray of an armored car to the ice-cold surface of a freshly Zambonied skating rink. Sometimes the boxes disappeared into their surroundings; other times they appeared heavy and solid as chunks of pure steel.

The former Army barrack in the museum where we lived was on the path of the group tour. Groups of Judd superfans, many resembling German DJs, looked in at me as they passed by our apartment and seemed confused to see me washing the dishes. Sometimes I smiled at them. Sometimes I waved. A few times I ducked.

I wondered what they thought when they saw me with my sponge and dish soap, doing my mundane housewife duties in the middle of the Mecca of Minimalist art. Not to mention the fact that I looked terrible; my son's birth had taken a lot out of me. I had been on bed rest for

months, hospitalized several times for hemorrhaging, and my C-section had required five blood transfusions. The pregnancy had also resulted in a flare-up of my long-term autoimmune disease, and I was exhausted from trying to work my job remotely while also taking care of a newborn and a little girl. In a photo of me eating ice cream at the Marfa Dairy Queen, I look terrible. I barely have enough hair to make a ponytail, and I look like I am suffering from both Stockholm syndrome and scurvy.

Not to mention, Marfa was a bit of a blow to my ego.

There are several art and writing residences in Marfa, which means that renowned and emerging artists and writers are almost as plentiful as cattlemen. And while most of those residents arrive on their own, some come with their spouses. So if those people on the Chinati tour knew anything about artist residencies, they might have recognized me as that most pathetic participant in the contemporary art world, the artist's wife accompanying her husband on a residency.

As a wife in the art world, your role is to look good or be a cool star yourself. As a breastfeeding, hair-losing office worker, I was a career liability for Rob. So I had to be the alternate kind of an artist's wife, the old-fashioned kind: the dutiful mother and homemaker who deals with every aspect of the children, from vaccinations to playdates, so the man can do nothing but make his art. And if the wife has artistic aspirations of her own, let's just say this role can occasionally result in some marital friction.

Despite my ambivalence toward my position as artist's wife, the residency itself and the people who ran it were wonderful. They even gave me my own studio in an old office space with a glorious bank of windows letting in warm Marfa light and providing a view of the train tracks.

Rob's studio was down the road from mine in an old ice factory. He took advantage of its towering ceilings and massive square footage to build a glass house. At the end of the residency, Rob had a performance where he and a friend got into the glass house and used a pulley in the ceiling to lift the sculpture to the top of the building. Then they each pulled on two chains, like men ringing church bells in a bell tower, and caused the sculpture to swing back and forth, with them swinging along inside it. With each swing, the glass house came closer and closer to hitting the factory's brick wall. The tension and suspense built, and with each swing, most of the crowd below them shielded their eyes or turned away.

Looking up at my husband swinging around in the air in that jewel of a box, I saw the metaphor of Rob soaring and me remaining grounded and practical. He flew; I made snacks. I did conference calls; he made art. It wasn't his fault. He had lived on his art long before I entered the picture.

The sculpture eventually hit the wall before swinging across the building to hit the other wall. Small shards of glass began to fall. Of course, the piece resonated with me so much. At that moment, I felt like a fragile person made of glass hitting wall after wall.

**I AM A PAINTER WHO HAS TO PUT IN THE HOURS TO GET RESULTS.** It takes me weeks of playing on canvas to create anything remotely decent. So I went to my studio anytime I could. Once there, I mixed bright yellows and bold blues, my palette brighter than usual in reaction to all that bright yellow sunlight leaving that bright blue sky and streaming through my studio windows.

My work often focuses on the sky, maybe from growing up under that endless one in South Dakota, and soon I had a bunch of paintings with huge, bright skies with stark horizon lines. A few weeks later, people began popping up in those paintings. A head here. The back of a head there. A blond ponytail. A man in a trucker's hat.

Some of those people were people I encountered online. In one painting, I tried to capture the young man who bagged my groceries and had a permanent air of amusement and long, black hair. I painted August. But I wasn't sure why those people were standing on my horizon lines.

Like most artists I know, a lot of my time in the studio is spent sitting and looking. I paint and then I sit and look at what I painted. In that temporary Marfa space, I only had a folding chair and a card table, so day after day I sat in that folding chair and stared at the paintings until one day I realized that the head of every person I had painted was tilted upward, almost imperceptibly, and that many of their features were consumed with bits of bright paint. What were they looking at? Why were their faces so bright?

Then it dawned on me: they were looking at the Marfa Lights.

And with that moment of clarity, I suddenly knew what I would paint. The series would be about a group of people all witnessing the lights of a UFO landing. Their faces lit up by the UFO's light. They became portraits of fictional strangers, a few people I know, and a few animals who witnessed the same UFO landing on a lonely highway, the sighting being the only thing linking their lives. I called the new series *We Are All Stardust*. Some of the people I painted were scared; others were hoping to be beamed up.

Despite the fact that I have never been abducted by aliens, trust me when I tell you that this work was all very personal.

When I was in the studio and working on those paintings, which were obviously about some sort of escape, I was able to escape the dishes and my status as the artist's wife. When I was in the studio, I was an artist, nothing else. Those few hours of painting saved me when I felt bad about myself and was not doing well physically. Just as has happened every time in my life, by returning to painting, I felt better. Not just in my mood and my outlook, but also in my health. I was able to think properly. My energy increased. I had a purpose beyond taking care of the people I love. I had my own story to tell and my own flight to take.

## Exercise: Tell a Story

Now you are going to tell a story through an image. Maybe about escape, or maybe about contentment. For this exercise, you can either paint on top of one of your existing landscapes or start from scratch.

You have some decisions to make going in.

What kind of world does your story take place in? You could depict a jungle, desert, country road, grocery store, hospital room, or snowy mountaintop. What details tell us about where we are and why we are there? A certain kind of flower, a hospital bed, a bald eagle, a homemade cake, or a bag of chips?

Who are the characters in your scene? If you want to insert people in your scene, you could paint them as is or do a simple silhouette and provide the bare minimum of information to let us know that it is a person. You could show us just a hand holding a teacup or a keg glass. Or if animals are your characters, a bird happily eating at a birdfeeder is one kind of story; a country road with a runaway cow on the road and a car coming over the hill is another kind of story entirely.

How can your palette help you tell this story? If your story is somber, create a palette of dark or muted hues. But maybe in that somber scene you want to point to the fact that there is a bit of hope by inserting a small, bright window or a star. If this story is joyful, brighten up your palette and lean into light greens, red, yellows, and bright blues.

## Exercise: Paint a Childhood Memory

If I were to paint the summer vacations I spent at the Vacation Village Resort in Iowa, I would paint a blue stripe of water to represent West Oko-

boji Lake and a stripe of brown for the beach. In the water, a bright gray swoosh would represent the long, dangerous, totally litigious, metal slide getting too hot in the sun. A few boxy red and white cabins would run up the hill. I want this to be a painting that represents the happy times I had there, so I will paint a bright sun in a blue sky and keep my palette light. The thing that made this great for me was all the time I got playing with my cousins, so I'll add a bunch of bright rectangles and black donut shapes representing the inflatables we lived on and fought over. I will paint the simplest human shapes in equally simplified bathing suits. Finally, I would add somebody flying down that hot slide and into the water to add some movement to my painting and create a focal point.

## Exercise: Paint the Scene of a Difficult Memory

If this is remotely troubling, skip this exercise. But I often feel better after I paint something hard. You could even paint it on paper and then rip it up.

Is there a place where you got your heart broken or said goodbye? Maybe it is a cemetery where somebody you love is buried or a school where you felt like an outsider.

Keep it simple. Paint the ground, a sky, and tombstones. A schoolroom with a few chairs and a blackboard. Paint using only black and white or a monochromatic scheme.

For a more intense, dramatic painting of a terrible moment, think of Edvard Munch's *The Scream* and try contrasting color schemes built around complementary colors.

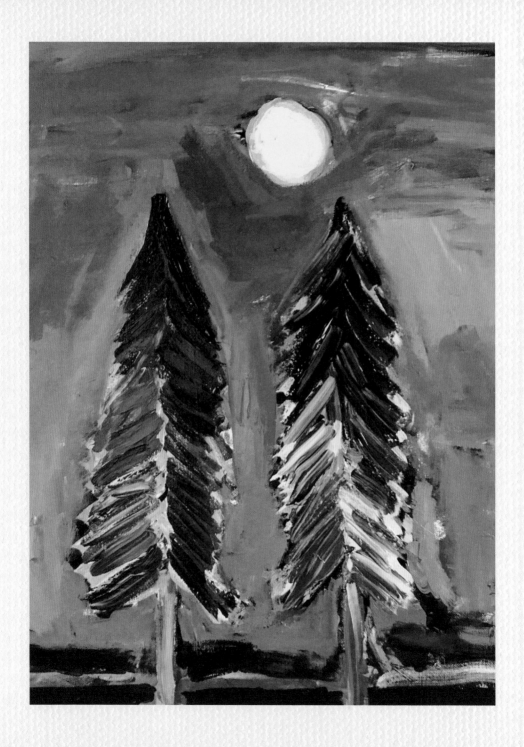

*chapter eleven*

## NOCTURNE

"Moonlight floods the whole sky from horizon to horizon;
How much it can fill your room depends on its window."
—RUMI

I should have seen it coming, this collision between my own ambitions as an artist and my role as an artist's wife with a day job. After all, a few years earlier I had been warned.

The tarot card reader was working out of the vestibule of a West Village bar, a hopelessly hip Manhattan place too cool for signage. It was the kind of place I hated but frequently wound up hanging out in because my friends cared deeply about being in the first ring of knowledge when it came to restaurant openings.

It was a work party for the advertising agency where I worked, and I was ready to leave after my first drink. The tarot card reader in the vestibule looked even more bored than I was, so I sat down at her card table.

Her red hair and beauty mark were both fake, and she looked more like a saloon girl in an episode of *Gunsmoke* than a mystic.

After turning over the first two cards, her expression grew concerned. One card had a sun peaking brightly over the top of some trees, and the other was an illustration of a quarter moon floating in a dark sky crowded with stars. They didn't look very troubling to me.

"This is the sun, the daylight." She tapped the first card. "This is where you are now. But you should be here, the moon, which represents the night. The day is like work. It usually refers to the ordinary, the common. This would be fine, except you are supposed to be living here, in the night, in the moonlight." She tapped the second card. "This is a dreamer card. You're supposed to be living in the night, not the daylight. You're not where you are supposed to be." I thought of the Oscar Wilde quote about a dreamer being someone who can only find his way by moonlight. "You are supposed to be an artist."

Supposed to be an artist? What a slap in the face. In my mind I was an artist, despite the day job. Wasn't the act of making the art what made you an artist? Did I have to survive on my art to earn the label? Besides, as the daughter of Midwestern pragmatists, I was not raised to live in the moonlight. I have a librarian mother with no junk drawer and a hatred for costume parties. My father goes to church a few times a week and keeps his lawn mowed. Those two people could have only raised a daughter practical enough to work in an office. Instead of moonlight, I lived under fluorescent bulbs that cast an unflattering glow on my putty-colored cubicle.

But the tarot card reader was onto something about me not belonging there. With the exception of two years spent as a receptionist at an

art college, I have not fit in at my jobs. I spent, and continue to spend, my workdays trying to master the vague office language tossed out on conference calls, phrases like "circling back" and "taking it offline." I am an organizational nightmare and experience constant anxiety from knowing that at any moment I might misread an office politics cue. I don't want to climb the ladder but am occasionally trampled by people who do.

But I tried to tell myself that it was okay to have an office job. After all, the fact that I worked to support my family and my expensive art supply habit was nothing to be ashamed of. Charlies Dickens worked, as did T. S. Eliot, Toni Morrison, Philip Glass, and William Carlos Williams. All kinds of artists had day jobs. William Burroughs worked as an exterminator. In fact, he wrote a book called *Exterminator!* Maybe I could write a book called *Cubicle!*

But the tarot card reader had a few more tricks up the sleeves of her off-the-shoulder, pirate-sleeved blouse. She flipped over a card featuring a macho man with massive forearms and an animal pelt slung over his shoulder.

"This is The Woodsman. He's here to help you, but you can't take his moonlight. You have to get your own."

"Do you know who this Woodsman is?" she asked as she took my money. I nodded.

"Don't steal his moonlight," she warned.

I knew The Woodsman, and it was a fact that he lived in the moonlight. It wasn't just that he stayed up until three or four o'clock in the morning making sculptures or hanging out with other artists in his studio; he is at his core a moon-loving, artistic soul. When I first met The

Woodsman many years ago, he was known in Minneapolis as the hot sculptor who lived on a boat on the Mississippi River. He drove around town on a motorcycle or at the wheel of an old pickup. He has brown hair and sky blue eyes, and his forearms and hands look as if they served as the model for Michelangelo's *David*. In fact, at the time of the tarot card reading, there was reason to believe he had never actually set foot in the daylight because, in the fifteen years that we had been friends, I wasn't sure if I had ever hung out with him when it wasn't dark outside.

And yet I, the girl whom people approached when they had trouble using PowerPoint, was suddenly, after years of platonic feelings toward The Woodsman, having a whole different category of feelings for him that included, and was possibly led by, lust.

It could never work. He lived in the moonlight; I lived in the daylight. If I was writing a romance novel and needed inspiration for the male lead, I would look at The Woodsman. If I was writing a dystopian book about an unfulfilled office worker in New York, I would look at myself.

But there was no doubt in my mind that The Woodsman card was a reference to my good friend Rob. As I sat in that terrible Manhattan bar, Rob was in the woods of Northern Minnesota building a giant studio. By himself. With his own two hands. His romantic ability to do things like build houses in the woods with his bare hands is not just more proof that he is basking in the moonlight; it is also part of the reason that I was attracted to him. Part of my ancestral ranch wife DNA sequence apparently requires a romantic interest to have brute strength and carpentry skills, somebody strong and brave enough to fend off a pack of wolves or a homegrown militia.

I HAD RECENTLY ESCAPED A TERRIBLE RELATIONSHIP, AND ROB HAD LEFT A LONG-TERM ONE, AND IT WAS THE FIRST TIME IN FIFTEEN YEARS OF KNOWING EACH OTHER THAT WE WERE SIMULTANEOUSLY SINGLE. Before he left New York for a summer in the woods, we had been spending a lot of time together. He gave me rides to parties. I met him at art openings. None of that was unusual; we often went places together. But there had been a barely perceptible shift in our interactions. A slight charge of sexual tension. A puff of heat.

"Set me up with one of your friends," I urged him over the phone soon after my latest breakup.

"I don't know anybody good enough for you," he responded.

What the oddly prescient tarot card reader did not predict is how a tragedy would have me trying to steal his moonlight sooner than I could have imagined.

Two weekends after that tarot card reading, a friend of Rob's and mine died unexpectedly. A few days after his death, on the night before the funeral, Rob and I were seated next to each other at a bar connected to a roadside motel in a small town in Central Wisconsin, surrounded by our oldest and closest friends. I had flown to Wisconsin from New York, and Rob had driven down from the woods. That weekend we tried to ease our grief with fast food, beer, and a jukebox full of old songs. We talked about our friend and worried about his girlfriend. We traveled as a pack, as if the power of old friendship could protect us from the loss, our grief, and the fact that life suddenly seemed to lack mercy and length.

I stayed especially close to Rob that weekend. He didn't look like my good friend anymore; he looked like somebody I might want to go on a date with. The sudden death of our friend was so jarring that it had

supercharged the feelings I already had for him and made me angry at how foolish I was being. Why was I wasting my one brief life with awful boyfriends and cubicles when there was Rob and all of his moonlight I could steal?

There were signs that Rob also felt about me in a new way, but that could not have been more confusing. Rob would never like somebody like me. I'd known all of his previous girlfriends. They are all extremely pretty, unpredictable, and very much living in the moonlight. Some of them are capable of doing things that could get them arrested. I am bubbly and scared of authority.

But two weeks later, Rob arrived at my Brooklyn apartment, straight off a plane, at eleven o'clock at night. In town for an art opening, he was tan, fit from all his carpentry, and shockingly good-looking in a white T-shirt and jeans. It was not unusual for Rob to stay with me if he needed a place to crash, but when he walked through the door of my apartment carrying a six-pack of beer and a small duffle bag, nothing about his arrival felt routine.

We sat on the couch of my railroad Brooklyn apartment and drank beer, and I tried, in my own pathetic way, to flirt with him. I flipped my hair and laughed at anything he said and generally behaved like a character on *Dawson's Creek*. He would later tell people that he knew the minute we kissed that he would marry me. I didn't know that because at that moment, in what was possibly the singular Buddhist moment of my entire life, I didn't care about the future or the past. And I certainly didn't care about the foreboding prophecy of our moonlight discrepancy.

But I should have been worried because it didn't take long for the tarot card reader's warning to come true.

I started stealing his moonlight.

It happened slowly, of course, as all insidious things do.

*Nocturne* is a term originally coined by Frederick Leyland, a collector of the artist James Abbot McNeil Whistler's work, to describe Whistler's series of paintings that capture the Thames at night, a series that is a meditation on illumination by moonlight.

Nocturne painting became popular in the late 1800s because it was a time in the world when many new and wonderful things were happening in regard to light sources and light quality, and artists wanted to

capture this. From the way the new gas lights being installed indoors added a tension to a scene of two lovers in a dark apartment, to the artists painting urban scenes in the electrical streetlights appearing in American and European cities in the 1870s and 1880s, artists captured how new light sources lit up people, buildings, and carts.

Edward Hopper used indoor, artificial lighting and neon signage to symbolize the loneliness of an American night. Munch's heartbreaking scenes in the sick glow of a lamp on the bedside table captured the final moments of someone's life.

Painting a nocturne painting is an artist's best chance to be moody and secretive, to celebrate the underbelly of the world, or to sync up with the wonderful things like fireflies and bonfire flames that can only shine in the darkness.

## Painting a Nocturne

Make your palette moody. I want to be respectful of your money and won't often encourage you to spend it recklessly on new paint colors, but the palette in a nocturne should be different from the palette you normally use because your light source is so different.

If you can, grab turquoise, phthalo green, and alizarin crimson. They combine to make complicated skies that allow the golds and yellows to truly glow.

Get into your own head. This is the perfect excuse to paint a dreamscape or a fantasy world. Or, if you are depicting a nighttime scene from a photograph, put on your moodiest music and go to your most magical and expressive place.

## Mixing Nocturne Colors

Here are a few interesting combinations to play with in your own moody scene:

- Use a combination of phthalo turquoise/turquoise + alizarin crimson for your dreamiest, darkest color and then mix it with increments of white to represent the lighter values where the moonlight hits objects.

- Add a little yellow to the darkest shade of that alizarin and turquoise combination. Add increments of white to that. What can you do with the resulting silver-green? Highlight the edge of a fir tree? Illuminate the surface of a bog?

- Use pinks, yellows, or oranges for your light sources instead of white.

- After you first fill your canvas, ask yourself, *Is there depth?* If not, make the sky cooler or the foreground warmer. Ask, *Is*

*there drama?* If not, make the contrast of the shadows and lights more pronounced.

- Want stars that glow in your dark blue sky? Try a yellow-orange blend.

- When mixing dark colors, it is hard to see exactly what color you are mixing. Pull out a tiny bit of the darker, mixed paint, and add a dot of white. The lightened version of your paint color will allow you to see if what you are mixing is turquoise or purple.

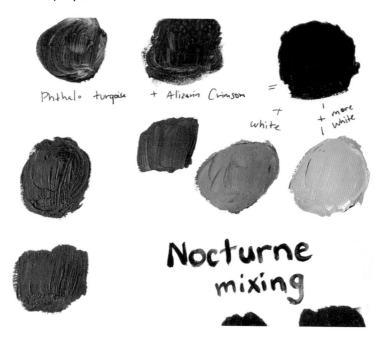

Phthalo turquoise + Alizarin Crimson =

+ white

+ more white

Nocturne mixing

# Exercise: Paint a Nocturne

This isn't just about mixing amazing dark shades and capturing how moonlight hits the surface of things. This glow in the darkness is a motif of your most magical spirit.

Think of a magical moment in your life that took place in the dark, in the night, at dusk, or under the stadium lights at Yankee Stadium. Were you at a rock show? On a cruise ship in the middle of the ocean looking at the starry night? What details do we need to see to place us there?

Ask yourself a few questions before you start painting:

- Where is your light source?
- How will light coming from that source impact the objects on your page?
- Where can you exaggerate the value shifts in order to make it even more dramatic?
- Are there any objects you can add to make this painting more significant?

How do you know if your nocturne is working? If you can answer yes to these three questions, it's working:

- Is there enough drama?
- Does it feel moody?
- Are your color choices different from the ones you make when painting a daytime scene?

Nocturne

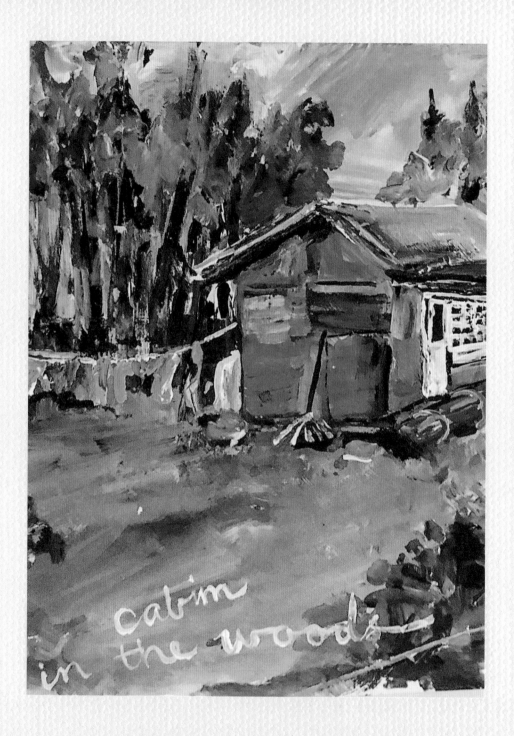

cabin
in the woods

*chapter twelve*

## MAKING DECISIONS

One year after our first kiss, I was married to Rob, pregnant with his child, living with him in a tiny cabin deep in the woods of Northern Minnesota, and already a bored housewife. Actually, I was a housewife without a house. Or a toilet—we had an outhouse. And maybe I was not as bored as I was isolated and without a sense of purpose; my only job was to funnel food into a fetus via an umbilical cord.

I had to find something to do or I wouldn't make it through the summer, so I told Rob that I would take care of the garden. It was the least I could do. Or, more accurately, it was the only thing I could do. I was hindered from doing anything else by my pregnancy and a total absence of skills.

Rob measured out a large parcel of land, grossly out of scale with the amount of interest I had in tending a garden. Ninety-nine percent of the plot contained boulders and required a three-day struggle to remove the

our cabin in the woods

rocks that had been nestled in the land since the Ice Age. By the time we were ready to plant the first seed, I already hated the garden.

On day one of planting, I knew that the gardener's buzz gardeners brag about is a myth. On day two, I realized that being in our tiny cabin on the worst day of summer is a thousand times better than being in the garden on the best day. By day three, I knew that growing food would remain just another activity from my family's farming past, like castrating bulls and laying barbed wire fences, which would not resurface with me.

The fantasy version of gardening that I had thanks to Martha Stewart was false. Gardening is not pretty, and not everybody wears little gardening gloves and glamorous straw hats. Some of us are covered in hordes of mosquitoes and struggle to repeatedly bend over in the blazing sun without throwing up or passing out. Even our Minnesota neighbors and good friends Amy and Aaron, a couple who tends to make many aspects of the

homesteading life look pretty picturesque, garden in gear that looks like something Meryl Streep would have worn in *Silkwood*. Meanwhile, I worked in the garden in my hot pink Helmut Lang silk dress, the only piece of clothing I fit into that would not make me die of heat stroke in the 90-degree heat, with nothing but a thick film of Off! Deep Woods separating me from the 5 billion mosquitoes that lived on our property.

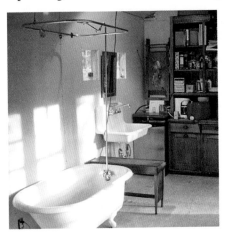

Gardening comes with a litany of rules regarding space and sunlight and water, and it turns out that I had broken every one of them. I made terrible decisions, planting aggressive squash next to delicate snap peas. The tomatoes were planted where there was too little sun, and I had never heard of thinning out beets.

The weeds we had spent days ripping out grew back more powerful than ever. Because bending over with my huge belly was impossible, weeding for me involved scooting down the rows on my butt like a toddler. So I stopped doing it, and the weeds began asphyxiating the plants one by one.

One day a neighbor, who looked exactly like Burt Reynolds in the 1970s, came over to the garden to say hi. He stood with his legs spread apart and glared at the garden.

"You've got too much stuff in there." This guy was real macho, the kind of macho you don't find in New York. The kind of macho you don't even find in Duluth.

"The tops of the beans keep falling down and snapping off," I told him.

"You just need to lead them a little." The neighbor stepped into the garden and gently took hold of one of the vines with his pinky finger and tucked it back into the fencing. He did it so gingerly, so lovingly, that I knew he must have a great garden, and he obviously had some sort of affection for the process and the plants that I didn't. I did not want to gently lead the pea shoots. I wanted to rip them from the soil, pour lighter fuel on them, and set them on fire.

Eventually I was so pregnant that I could no more drag the hose into the garden than I could bend and touch my toes, and Rob was preoccupied with other projects. The garden was abandoned. Some of the more stubborn plants with a strong will to live managed to push their way out of the parched soil only to die from the drought above ground. The plants that thrived despite their neglect proved their feral nature by growing wildly large. The zucchinis became so huge and phallic that I blushed looking at them. The microgreens could have starred in *Little Shop of Horrors*. A deer pushing past the fencing trampled the green beans, and the tomatoes were destroyed by what I can only assume was a plague of locusts seconds after they turned red.

Nothing within that garden would reveal that I am from generation after generation of farmers and ranchers. Since the Jorgensons arrived from Norway many generations ago and the Wosters sailed over from Bohemia and the McManuses left Ireland, farming is what we did. Whatever gene that dictated a person's ability to do things like growing winter wheat or harvesting oats must have been pretty weak to be rendered useless in one generation.

JUST BEFORE THE BABY WAS BORN WE HAD WHAT COULD LOOSELY BE CALLED A HARVEST. In that wild patch of land I uncovered a single ripe tomato, a few gamey green beans, and a stalk of stringy broccoli. I made some pesto with the abundance of what proved to be a strain of unkillable basil. Rob and I sat down to eat the most unappetizing meal of my life. The produce was so wild and tough that chewing it reminded me of the scene in *Mommie Dearest* when Christina is force-fed the steak. I gagged when I should have been swallowing.

But I got what I deserved. You cannot create something without love, or at the bare minimum, affection. And you cannot create something beautiful without knowing what kind of decisions need to be made to get you from A (nothing) to B (something beautiful). Just as learning about how much sunlight a plant needs would have informed the decisions I made when planting and tending my garden, and drastically improved my chances of success, so is the case with painting.

AS A PAINTER, THERE ARE TWO SIDES TO YOUR JOB. One side is to reveal yourself or to serve as a conduit to the world, transposing something onto the canvas that comes from deep within yourself or is inspired by the world around you. But at the same time, you have to be a person of logic, somebody who sees your painting as a series of informed and thoughtful actions.

Learning what decisions to make at key stages of making a painting will drastically increase your chances of painting something that you love. All the things you've learned so far, like warm versus cool, light and

shadow, and space and composition, will be called forward when it comes time to make each individual decision.

Think about all the decisions you must make at the moment when you are to paint the sky of a seascape. Do you want to paint a sky with endless depth like you see when you look over the ocean? If so, put a cooler blue or gray in your sky.

Should you place an object in that sky? What happens if you add a seagull or some storm clouds? A sun? A moon? How will it impact the balance of your composition? Ask yourself if there is more value in adding the birds or the storm clouds in terms of the story you are telling. Do you want to create a certain mood? A few storm clouds might add a sense of gloom, whereas a bird in flight signals freedom. And objects are great depth and perspective tools. Painting larger birds in the front and smaller birds in the back tricks the eye into thinking that your sky goes on forever. But would adding too many birds ruin the composition? Maybe your scene doesn't yet have a dynamic composition, and adding a single bird in a slightly off-center way, right at one of those rule of thirds intersections, can bring your canvas to life.

So many decisions to make in one image.

LET'S LOOK AT THE DECISIONS AN ARTIST MADE TO CREATE A FEW FAMOUS ARTWORKS. When painting the Sistine Chapel, Michelangelo put the pinkish Adam on a greenish rock. This makes the warm thing (Adam) emerge from the painting as the cool thing (the rock) recedes into the background. If Adam's skin had blue in it on a rock

with an orangish hue, it would have resulted in something else entirely. Michelangelo made the decision to stop the fingers of God and Adam from actually touching, creating an anticipation of the moment when the fingers will touch and kickstart the world. It is maybe the greatest moment of tension in visual imagery until Steven Spielberg modernized the idea for the billboards for *E.T.*

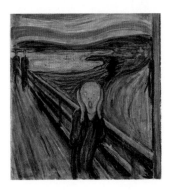

Munch's *Scream* is another example of a masterpiece resulting from a string of smart decisions. Munch puts the screamer in the front, so close to the viewer that only the top portion of the body is in the frame. He could have included the entire body, but by just giving us the torso, it feels as if the screamer is moving toward us, out of the frame, which creates a feeling of unease because nobody wants a screaming stranger coming at them.

Munch adds a slanted walkway disappearing into the background to give depth through perspective. And then, for good measure, he adds two small figures who don't just give us additional depth; they also heighten the energy of the piece by making them witnesses to this person spiraling into madness.

## Exercise: Spot Decisions in Famous Artworks

Spend some time looking at your favorite paintings, not as a final product, but as a series of decisions, and you will be surprised at how obvious the artist's choices become.

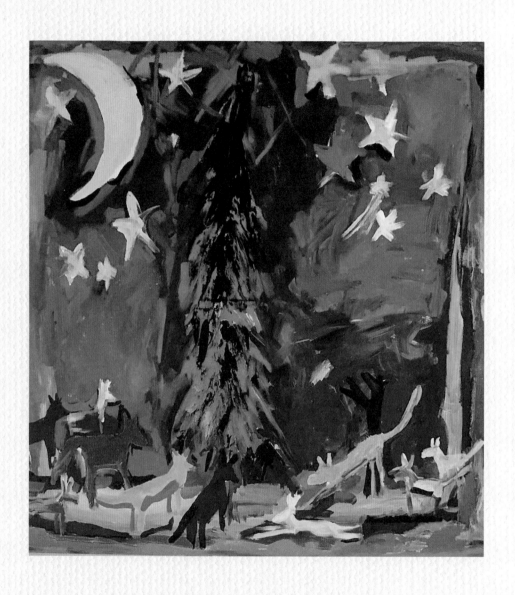

*chapter thirteen*

## ARBITRARY COLORS

Most of my closest friendships are all centered around the arts in one way or another. Many of those close friends I met through the art college in Minneapolis in the early 1990s. I was an interloper, a visitor from the less expensive state university across town. But I preferred the energy of the art college, where I shared the loosey-goosey attitude of the students toward sexuality, clothing, and lifestyle—I don't really care what anybody does on their own time or what color hair they have. I loved the conversations being had and music being played at their parties. I was inspired by how they encouraged each other to push their art and take risks. They were willing to expose wildly personal things and then sit back and let a room full of their peers critique them about it. The intimacy in the art they shared with one another translated into a strong sense of community at the school. And, like those art school students, I wanted to make stuff all the time, too.

I was also drawn to the school because most of the people there also

seemed to have something slightly off-kilter in them—too much anxiety, too much energy, too much sadness, or too much anger. My friend Amy says of our group of artist friends that we are all functioning at a similar, too-high, RPM. And as somebody who was boy crazy for much of my life, I should point out that I preferred the art school guys to the boys at the frat houses; Rob and I first met on a deck at one of those art school parties when I was nineteen and he was twenty-one.

Those friends went on to show their work in museums, teach art, edit and art direct films, make music videos, run scenic shops, open galleries, and just generally center their lives around creativity. Much of their success can be traced back to the community and competitiveness that fueled their art during those college years. Throughout history, great work has been born of artistic friendships that are centered on bravery and experimentation but were also a bit of a rivalry.

ARTISTS FROM CULTURES ALL OVER THE WORLD HAVE A LONG HISTORY OF ART FULL OF BOLD, IMAGINATIVE COLOR CHOICES THAT DON'T REFLECT REALITY. Aboriginal art used bold color. The Japanese artist Hokusai was not opposed to creating a red Mount Fuji. But Western artists were generally focused on capturing the exact green shade of the skin of a pear or the pink flush of a cheek . . . until André Derain and Henri Matisse spent the summer of 1905 hanging out together in the South of France. Both had been making art aligned with the Impressionist movement, but that summer they experimented with bold and unnatural colors.

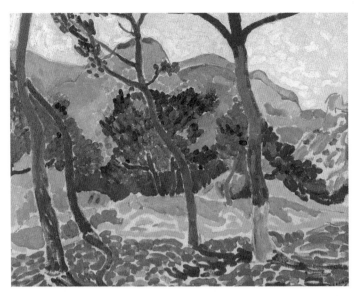

Encouraged by what the other was doing, the men pushed back on what had been the conventional rules of color to experiment with what we now call arbitrary color, the idea that any color can be used for anything.

Derain did a portrait of Picasso with his face full of green and red shadows. Matisse painted the view from his window with a purple sky and a pink and teal sea.

The contrasting and bold colors they used resulted in an expressive mosaic built of short, aggressive strokes. This kind of painting is so normal now that it is difficult to imagine how radical a departure painting with arbitrary color was for Western art. But when the two artists and their equally radical friends exhibited this new style of work in the renowned Salon d'Automne in Paris later that year, an exhibit considered a key moment in Western art history, people were shocked.

Matisse exhibited *Woman with a Hat*, a painting of his wife, Amélie, painted with bold, flat brushstrokes and countless wild colors. Forget

matching a skin tone, Amélie's face is green and turquoise, her neck orange, and the whites of her eyes light blue. Her dress is wild purple and green, pastels and muted blues despite the fact that Matisse said she had worn a black dress that day.

The artists' wild color choices earned them the nickname *les Fauves*, or "wild beasts." In the incredibly expressive work by Matisse, Derain, and the other Fauvists, shapes were simplified and the artists attached their extraordinary colors to ordinary objects. Arbitrary color changed everything for artists; you could paint all the trees in your forest dark purple and create a haunted landscape reflecting a haunted soul. Color could now match a painter's emotion.

They weren't outliers for long. Other artists adopted arbitrary color, and the Expressionist movement was launched as artists now focused on getting their heart and soul onto the page rather than representing the world as it is.

This story demonstrates just how powerful a group of artist friends can be. Matisse and Derain met in an art class. Their friends Paul Gauguin and Franz Marc agreed with them that there was no reason that a horse could not be painted blue. Friends Georges Braque and Pablo Picasso expanded Fauvism into Cubism, while another group of friends, Wassily Kandinsky, Otto Dix, Max Ernst, and Ludwig Kirchner, launched German Expressionism on Fauvism's back. (I know, it was a real boy's club.)

Countless other groups of friends over the years have advanced art through their collective experimentation. The famous Mexican muralists Los Tres Grandes. Harlem Renaissance painters Beauford Delaney, Jacob Lawrence, Aaron Douglas, and Loïs Mailou Jones. The Guerrilla Girls.

The Bloomsbury artists. The Gutai movement in Japan. In Los Angeles in the 1970s, an arts collective called Asco politicized street theater, and in the 1980s, a graffiti-inspired art movement was launched by Jean-Michael Basquiat, Feb 5 Freddy, and Lady Pink. And somewhere in the world today, a group of friends who are artists are hard at work pushing art to its next new place.

## Exercises

Here's how to paint like a Fauvist:

- Mix bright, bold colors. Fauvism happened because of an advancement in the bold pigments that manufacturers were able to create. For this you can even use color directly from the tube.

- Much of your canvas should include active, energetic marks of bright color, but even the contrast-loving Fauvists painted some sections in less intense color, like black or natural colors, to give the viewer's eyes a place to take a break.

- Simplify your composition, or the canvas might become messy mayhem. Paint fewer details and more larger blocks of color.

- Reconsider every color urge. When painting a tree, fight the urge to dip your brush into green and brown. Derain did red

trees with purple trunks, pink grass, and purple skies. Munch did bright yellow ones.

- Most of all, be playful with your marks.

## Exercise: Paint a Fauvist Painting

Let's return to whichever exercise you most enjoyed doing, whether it was painting a still life, a landscape, or a portrait. Reimagine one of your existing paintings by replacing all of the perceived colors with arbitrary colors.

## Exercise: Paint a Cool & Warm Arbitrary Portrait

Now might be a good time to try another self-portrait. This time forget about getting your skin tone just right, and build out your face using expressive colors and brush marks. Where you would paint the actual color of your skin, instead choose colors in terms of how warm or cool

they are. So if you want the nose on your portrait to protrude, paint the tip of it a warm color like yellow or orange. Because you want the eye sockets to recede, paint a dark blue or green around your eyes. You also could outline your portrait in thick, expressive, black lines and then fill them in with bold colors.

If the resulting portrait is too intense with too many colors, let it dry and then go back in with neutrals to tone down portions of it.

*chapter fourteen*

## INTERIORS

"I don't make portraits, I paint people in their homes."
—JEAN-ÉDOUARD VUILLARD

My parents still live in the house where I was born, never tempted to buy a bigger house or migrate to the Sun Belt. The layout of the living room never changes: couch by the big window, one chair for my mom with a floor lamp by it for quilting and reading, and a recliner for my dad right next to the cordless phone because even at eighty years old, he gets twenty times as many calls as I do. The dining room table just fit the five of us, and the kitchen is small, bright, and spotless.

As if to make up for all those years of living in one place, I have lived in a dizzying number of apartments as an adult.

The view of the Chrysler Building lulled me to sleep at night in the Gramercy studio I shared with my best friend from Minneapolis, my

first New York apartment. We lived on the eighteenth floor of a doorman building, and I never once interacted with a neighbor.

The red, ridiculously overpriced, mid-century sofa owned by my boyfriend was the focal point of the Soho loft we shared. The sofa was so expensive that I was too nervous to eat popcorn on it while watching a movie, much less paint near it. In the end, the couch symbolized everything wrong with that relationship, and not long after moving in, I packed my belongings into three garbage bags and headed to a Fort Greene sublet.

To capture that Fort Greene studio, I would paint it as a tall, bright space, even though the windows were filthy with exhaust from the busy street below. I was drawn to those windows the day after 9/11 by the sound of horse hooves on Brooklyn pavement. I cried as I watched a group of Black cowboys ride by on horseback, solemnly carrying American flags, as grieving New Yorkers lined the street to watch them pass.

If I was painting my Williamsburg railroad apartment, I would exaggerate the already extremely tilted wooden floor of the kitchen—anything with any kind of round edge rolled across the room if you dropped it. Whenever we had big parties, I worried about the floor collapsing under the weight of all the people. I would paint the two kitchen windows overlooking a back garden that we shared with the other two tenants in our building. Cold air streamed through those old window frames in the winter.

I watched the backyard activities of my hipster neighbors from our kitchen window for five years. One warm summer day, during a torrential bit of rain, my next-door neighbor ran into her backyard totally naked and danced in the rain. On the first 4th of July after 9/11, a stealth

Interiors

bomber flew overhead, and the entire neighborhood, everybody standing in their own backyards and on their rooftops, booed it. Nobody wanted to see another deadly airplane in the sky. Backyards and roofs make great locations for interior paintings, too.

The intersection where our next apartment sat was the heart of the drug trade in that part of Brooklyn. At eleven in the morning, a procession of people, many of them limping or using canes, passed by our house on their way to buy opioids, reminding me of the procession of the infirmed I had witnessed in Lourdes years before.

Rob's studio was in the garage attached to our apartment building, and he worked with his door open, so he got to know a lot of the men buying drugs. One man showed up each day to sell Rob rolls of packing tape, empty picture frames, or an old knife, discarded items from garbage day. Rob always bought something because he was deeply impacted by the people and the similarity of their aches and pains to his own. Rob had put himself through college roofing houses and followed that with years of sculpture and carpentry, so his body is filled with destroyed cartilage. While we lived in that apartment, he had surgery to fix a decimated kneecap.

"These people are addicted to painkillers because they are in constant pain and can't afford to fix it, and they probably hurt themselves doing work on some unregulated job site," Rob said. "If we didn't have health insurance, I might be where they are in ten years."

Gabriel stopped by Rob's studio, too. He was skinny with a long, Rasputin beard and was kind to our baby, offering her beads with fake backstories.

Holding out a black, seemingly plastic bead, he told us, "This was a

gem given to me by the Queen of Prussia. It is a black lapis." Of a simple white ceramic bead, he might tell us something like, "This is made of the bone of a prehistoric reindeer."

An interior of that place would include the ceramic mug where we kept those beads or Rob's studio full of tape.

Our next place had an 85½ address to prove just how extra small it was. During playdates, the other mothers looked distressed. When my son was born, we brought him and all his baby stuff home, and the four of us living in 500 square feet became untenable. That interior painting would be stacks of books and canvases, toys, papers, with my paintings stacked everywhere, until the viewer was claustrophobic and over-whelmed.

Our next apartment over the pizza place had so many constant and unsettling noises, like the fan of the pizza oven and the screeching brakes at the bus stop. The smells were horrible, too, burnt red pepper being the worst of them. The room was barren; we couldn't afford to buy a new couch, and I had refused to move the old one again. In that interior, I would paint the bean bags we sat on for a year.

Our apartment in Brooklyn is a basement apartment with a kitchen full of wood paneling that looks like it belongs in a grandma's house in the 1970s. We can't get rid of the mice. But we have enough closet space, and if I painted this space, it would be of our lush backyard overflowing with our friends and their kids during a loud, summer BBQ.

We are the loudest people on our quiet block. There are none of the same noises we had in our other Brooklyn apartments: the 1970s love songs or hip-hop blasting from car stereos, the horns on the boats in the East River, the cleanup crews at the restaurants flapping the rubber kitchen

mats, the tattoo parlor's security gate coming down, people tossing house keys out of fourth-floor windows.

Most of my current neighbors are silent; I never hear them, and I never see them on their stoops unless they are stretching out their hamstrings before going for a run. I did uncover the few loud people who live here. The people who hosted drinks on their stoops long before COVID-19 forced them to do so. The people who get super competitive at musical chairs during street parties and who, on their way home from seeing live music, knock on the back door of the famed Italian bakery and beg the overnight bakers to give them a loaf of lard bread, hot from the oven, in exchange for a five-dollar bill.

I LOVE PAINTINGS OF PERSONAL SPACES. I love Matisse's paintings of his studio, Vuillard's rooms constructed of endless combinations of patterned wallpaper and bedding, and the vanity crowded with bottles and lotion in a painting of a dressing table by Toyin Ojih Odutola. Which is better, Fairfield Porter's WASPy portraits of life by the sea or Andrew Wyeth's spartan, sunny corners?

A room is an amazing storytelling device. Three of the four walls become a theater set, and everything inside of those walls acts as props for telling the story of the people who move around the room.

Interior paintings from the olden days were serious and overstuffed with fancy chairs and chandeliers because the story those paintings intended to tell was of how incredibly wealthy the owners of that room were and how much nice stuff they could afford to buy. As realism be-

came in vogue, artists focused on the commonplace, and there followed a period of dreary depictions of artist studios and dark apartments overrun with nefarious men. Vuillard is famous for his texture-filled interiors where we see his family members from behind or in the shadows, as if we were stepping into the home and the painting captures the split second before the family realizes we are there.

Then artists played with their spaces. Frida Kahlo turned her physical space, especially her bed, into a magical realm. David Hockney painted impossible structures with tilted walls and messed-up perspective, and Rose Hilton did interiors so bursting with flower patterns, flowers in vases, and flowers visible out her window that she practically suffocates you with all the flowers. Roy Lichtenstein created comic book rooms full of thick, black lines and polka dot patterns.

Details in an interior are important. When I see Alice Neel's painting of a raw chicken in a sink, a can of Ajax on the edge, and dishes in a drying rack, I see a study of a woman with artistic aspirations dealing with domestic duties. Somebody else might read it as a study of economic struggle, as the chicken looks past its prime. Details tell a story, but they might not tell the same story to every person.

You can play with time and space in an interior. A contemporary American painter from Pakistan named Salman Toor paints images of friends and lovers drenched in antiquated and historic-looking hues you might find in a portrait of an old sailor or an antique illustration of a mermaid. But they are modern-day scenes, so they include power cords, cell phones, and open laptops hinting at doom scrolling or online dating.

Interiors go beyond depicting the objects people own and the design decisions they make to tell the stories of the humans who live there. The best interiors do not tell stories about stuff; they tell stories about people.

## Things to Think About in an Interior Painting

### Mood

Is the room you want to paint filled with ghosts from your past? Play up shadows, and darken underneath the bed. Is this a room overflowing with joy? Brighten up the light source, and intensify the colors. Make your palette warmer than usual.

### Storytelling

Let's look at an interior done by Horace Pippin, *Christmas Morning, Breakfast*. The details, from the pretty tree with the gifts under it to bits

of garland, tell us it is Christmastime, so we assume that the people living in the house are Christians. They are obviously not terribly wealthy; they have rag rugs on the floors, and the walls are beat up. But they don't seem to be destitute either; they are nicely dressed, and there are presents under the tree.

PAINTING CAN SAVE YOUR LIFE

This interior is a childhood memory of Pippin's, and his storytelling details tell us a lot. Somebody cared enough to decorate the tree and buy the gifts; his mother is handing him a slice of cake that she probably baked for him. But the alignment of her body tells us she might be tired or working hard to take care of her son while keeping the holiday spirit alive. That is a lot of story in one frame.

## Symbolism

The entire next chapter is dedicated to symbolism, but know that you can make an interior more powerful and distinct by inserting symbols into the painting.

### Exercise: Paint an Important Room

Your goal is to create paintings that matter to you, so let's paint a room that matters to you. One of my students painted an amazing, monochromatic painting of her childhood bedroom in a pale, 1980s fog of peach and teal, as her oasis in a home with marital chaos. Another friend was so inspired by Matisse's work that she painted his studio.

How will a viewer know this room is important to you? Is it your dining room, where your family gathers every night? What items on that table signify why that time at the table is important? If your favorite room is your living room because of the couch you bought with your first paycheck, make the composition center on that couch.

Before you start painting, consider your decisions. How will you play with light and shadow or warm and cool colors? What is innately working in the composition? What should be ignored to make the composition stronger?

## Exercise: Paint a Room in Your Home, Marie Kondo Style

For most of us, painting everything in our room would result in a cluttered image without anywhere for the eyes to land. To paint an interior that tells a story, you must first decide what to leave out. In this exercise, you will carefully consider each item in a space in order to see what you should paint and what you should not.

Challenge yourself to remove three-quarters of the items that are actually in the room. Ask yourself if each framed item on your wall, each perfume bottle on your dresser, each shoe on the floor tells us something about you. If it does, leave it. If it is an inconsequential bit of debris, either physically remove it from the room or just skip over it as you paint your room and focus on the importance of the items that remain.

While you are culling objects, think of how the addition or subtraction of one object will impact the composition. Should you move a blue vase to the left for an asymmetrical composition?

Would it help to tweak or subdue the colors? Should you make the red color of your dresser more vibrant than it is in real life? Or is it more important to honestly depict the scene than to create more color contrast?

## Exercise: Paint the View Out Your Window

Find inspiration in the amazing painter Lois Dodd, and paint a scene where a window takes up 50 to 75 percent of the page or canvas. Consider that whatever is outside of your window is going to be farther away; it will not just be smaller; it will have fewer details and be a little darker as it moves back in space, away from the objects in your home.

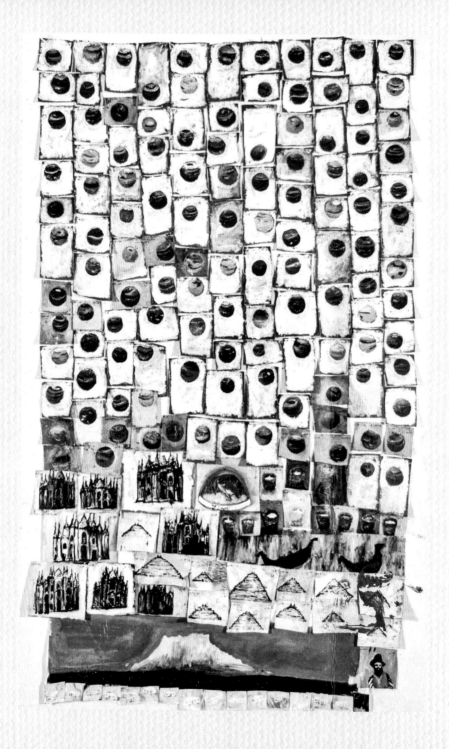

*chapter fifteen*

## SYMBOLISM & STILL LIFE

The summer camp that I worked at in the French Pyrenees Mountains was located in a town of fewer than 100 people. It had a few houses, a church, a cemetery, our camp, some mountain goats, and a lovely old man in a three-piece suit who sat on the edge of the mountain and played his accordion.

It was an "American immersion" camp designed to teach French children about American culture and help them perfect their English. Unfortunately for those kids, the only experience any of us had with American culture was being American. Only two people had degrees related to children, and we certainly weren't educated in ESL; we were recent college grads just looking for a way to spend the summer in Europe. This resulted in a DIY camp schedule filled with activities designed around nothing more than our collective desire to do them and the random assortment of supplies we had on hand.

The immersion in American holidays that the French parents were

promised meant celebrating the 4th of July with a lame parade through town as the kids waved homemade construction paper American flags and sang the song they most associated with America, the theme from the TV show *Cops*. On Halloween, we staged a terrifying haunted walk down a nearby pitch-black abandoned road, made even more scary by the fact that horror culture is not a big part of the French childhood.

We bought plastic sheeting from a local gravel pit for a slip-and-slide. Our families shipped jars of Ragu from the States so we could introduce them to American cuisine. We opened a "commissary" that we stocked with the candy our families bought in bulk in America. We sold Fun Dip, Ring Pops, and Pop Rocks for ten times the price. And one day a week, we took a bus trip through the Pyrenees to a nearby swimming pool, a ride so winding and nauseating that we walked the aisle of the bus with plastic bags just waiting for a kid to vomit.

It was a magical summer for me. It was never too hot on the mountain, and the food was amazing. When we took the kids hiking, the camp's cook drove fresh baguettes, hard-boiled eggs, and juicy tomatoes up the mountain for us. We ate hearty Basque foods for dinner, pots full of braised meat and vegetables, merguez sausage, and potatoes. On our days off, we hitchhiked to the coast of Spain or caught a ride to the running of the bulls in Pamplona. In the mornings, I looked out of the tiny window of my bedroom at the mist-covered mountain peaks and the cows with bells around their neck and reminded myself, "You live in the mountains. You live in France." Because when you are on an adventure, it normalizes quickly and you must keep reminding yourself how lucky you are.

During one camp session, an adorable, round-faced boy with a shy smile arrived. He was assigned to my group and given the supposedly American name of Cliff Avocado. Cliff and I hit it off, and he followed me around camp and frequently showed up in the arts and crafts room where I worked.

On the final night of camp, we had a dance. We decorated the meeting room with streamers and blasted both French dance music and American pop. At one point in the night, Cliff's friend came to me and explained in his (not-at-all-improved English) that Cliff was crying in the boy's dormitory. I hurried upstairs and found Cliff Avocado face-down on his cot.

"Are you sad to leave?" I asked. He nodded.

Cliff reached under his pillow and pulled out a tiny cardboard box that he handed to me. Inside the box, nestled in some grass, was the baby tooth he had lost earlier that day.

That tooth was such an awesome symbol of his affection for me; he gave me an actual part of himself.

I was knee deep in symbolism that summer myself. I had left a relatively new boyfriend back in Minnesota, a boy with curly hair who was doing research for his PhD around something that sounded like science fiction at the time but was actually the early stages of gene therapy. I had met him not long before I left for France, and my absence had turned us both into letter-writing romantics. Thick envelopes filled with the sonnets of Pablo Neruda and Leonard Cohen lyrics and covered in red and blue air mail markings sailed back and forth across the Atlantic.

My letters were filled with symbols of my French life and my affec-

tion, drawings, collages, bits of French branding, and once, in my ulti-
mate symbolic romantic gesture of the summer, the actual x-ray of my
heart (and lungs) that the French government required me to have in
order to prove that I wouldn't infect the kids with tuberculosis.

A FEW YEARS AFTER I RETURNED FROM FRANCE, I WAS AWARDED
A FELLOWSHIP THAT INCLUDED PARTICIPATION IN AN EX-
HIBIT. For that show, I made hundreds of small oil paintings. Those
paintings repeated the same symbols over and over: disco balls, tigers,
witches, storm clouds, boys, parade floats, churches, candles. Some of
the symbolism I recognized at the time; some of the symbolism I didn't
understand until years later.

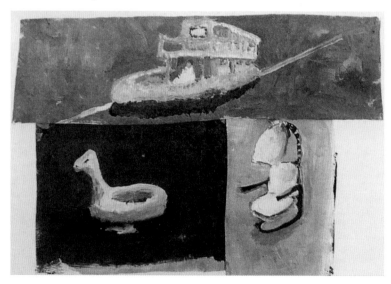

I worked with the gallery's art handlers to hang the paintings, and the resulting piece was a massive, symbolic storyboard of my life that wrapped around three walls of the gallery and told my story of family, boys, dreams, summers, weather, dancing, friends, heartache, my Catholic upbringing, and joy. I titled it *The Patron Saint of Desperate Causes* after a mass I had attended at Sacré-Coeur in Paris that honored St. Jude—a title that proved just how melodramatically I viewed my life at the age of twenty-six.

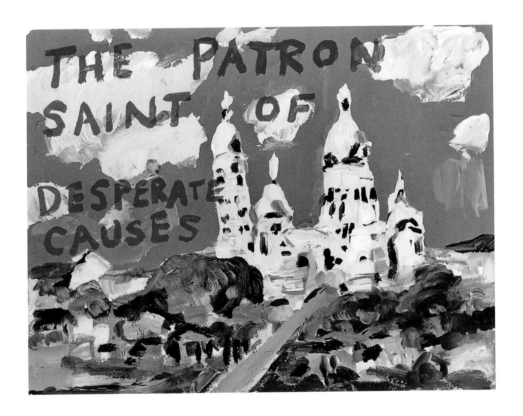

St. Jude is on the medal that Catholics cling to in their most hopeless times or when comfort is needed. He is worn around our necks or draped over Virgin Marys. He is grabbed when you don't have faith that things will get better without some help, and he is the saint I most often see hanging on shrines dedicated to the Virgin Mary when I walk my dog through my Italian American neighborhood. As I write this in 2020, turning to the symbol designed to help us survive the most desperate moments does not seem like such a terrible idea.

## Symbols

By now you know how to create a painting that reflects your growing knowledge of the visual elements, but what's the point in making a painting if it isn't also telling the viewer about you, your feelings, or how you see the world? This is where symbolism comes in. Objects or symbols can be inserted into paintings to give the viewer more information about the painter and their intent.

Symbols have always been important in painting. Navajo sand paintings use pictorial symbols. René Magritte painted balusters to represent people and apples to represent mankind. Gertrude Abercrombie filled her paintings with cats and owls and women wandering the night—all symbols related to witches (not surprising coming from a woman who often walked around town in a witch's hat). Forrest Bess featured an entire symbolic language about gender fluidity in his work. Florine Stettheimer's red shoes symbolize femininity, power, and parties. The Chicano artist Mel Casas combined things we think of as relevant to "American" culture, like brownies and action heroes, with symbols of Mexican culture or history. Jean-Michel Basquiat repeatedly used a crown as a symbol of royalty and kings. Kara Walker repeats imagery of slave ships and cotton in her depiction of Black history and white supremacy. Through her endless polka dots, Yayoi Kusama wants us to think of ourselves as just another dot in a sprawling universe. And one of my favorite contemporary painters, Tala Madani, uses things like light, cake, and naked men as symbols of the absurdity and horrors of our complicated world.

Specific types of still life genres are entirely built around symbolism.

A *memento mori* still life reminds us of our mortality by filling a canvas with symbols of death, like skulls, hourglasses, and flowers. A vanitas is a symbolic painting that captures the brevity of life with fleeting things like smoke, rotten fruit, and bubbles.

## Exercise: Build Your Personal Library of Symbols

Think of three things that matter to you. Maybe it is where you are from, or the ocean, or maybe it is music. How can you symbolize those meaningful things in your painting? Maybe a seashell in your still life becomes a symbol for your childhood on the water. If music is what obsesses you, you could repeat the black-and-white rectangles of piano keys along the edge of your painting. A symbol could be a childhood treasure, a shaft of wheat, a simplified hand, your astrological sign, a Star of David, or a cross.

Think of as many symbols of the various aspects of you and your life as you can. Then fill a canvas or piece of paper with them, thinking of color and composition. In the end, you might have an amazing portrait of you as told by the things that symbolize you.

## Exercise: Insert Symbols into a Previous Work

Return to one of your earlier paintings. See where you might insert one or two objects from your symbol library to make that painting more meaningful, doing so in a way that makes sense in regard to composition and depth. If it is a self-portrait, maybe you paint some earrings that you inherited from your grandmother onto your ears. For an interior, add an urn holding the remains of your beloved cat on a table. Just be sure to paint it where it improves the composition, not harms it.

## Exercise: Build a Still Life of Symbols

What kind of still life could you build to show what you value in life or who you are? This builds on the previous exercises of treasured objects. You have more skills, so now you can paint your treasured objects and other symbols with more details, a better sense of color and shadow, and stronger color schemes.

## Exercise: Paint a Symbolic Food Still Life

Another genre of still life is a Spanish *bodegón*. A bodegón typically included pantry items or wine and, back when bodegones were first being painted, a dead rabbit. They often had dark, moody backgrounds. If I were painting a bodegón to symbolize the foods my daughter most loves, I would include a jar of Nutella, strawberries, dumplings, and bubble tea. For my son, I would paint a jar of Nutella, pasta, orange Tic Tacs, and BBQ chicken wings. For myself, I would paint vegetables, a pile of cheese and crackers, some wine, and a chocolate donut. Paint a bodegón about yourself.

## Exercise: Paint Shiny & Reflective Things

The painting of shiny things deserves its own focus when we talk about symbolism because so many of the things that we cherish, and are, therefore, symbolic of us, are shiny. Watches, jewelry, and glass are all shiny. Or they are reflective surfaces like metal and mirrors that require you to observe closely what in the surrounding area is being reflected on the surface.

Here are some things to know when painting glass:

- Glass usually includes a wide variety of shadows, from very dark to very faint.

- If you put your glass object against a dark background, it makes the reflections in the glass more visible and allows you to see the highlights. Painting glass is all about capturing the highlights.

- Highlights in glass sometimes have bold colors running along the edge. If you are painting an indentation in a crystal glass, for example, you might see bits of red, green, or blue.

- Remember to capture whatever is visible behind your glass, too.

And here are some things to know when painting shiny metals:

- The key to painting shiny metals well is to capture the strange, often warped, bits of light and shadow in the metal. This is an observation game.

- Whatever is around your reflective object will be visible on it, so pay attention to any cast shadows from nearby objects. And if the metal is reflecting any of the colors of the objects around it, those reflected colors will not be as intense in the reflection as the colors on the actual objects.

- Pay attention to whether your metal is very reflective or kind of dull. More reflective metal will have more contrast, more variation of shapes, and sharper edges on the shadows. Duller metal will have more subtle shifts in value.

- Consider where your light source is located. Anything facing the light will have brighter, hotter highlights.

## Exercise: Shiny, Glass & Reflective Objects Still Life

Build a still life with one shiny thing, like a diamond ring or watch; one glass thing, and one metallic thing. Add something bright next to the metallic object so you can practice painting a colored reflection on your metallic surface. I would put an orange or lemon in your still life next to the metal, or something else bright and simple.

Having your light source closer to the objects ensures the shadows and lights are well defined. Spend a moment moving your objects to make a pleasing composition. If your still life includes a shiny spoon, consider which direction the handle should go.

Hanging a piece of black or dark fabric behind your still life will make it easier to see the reflections and bits of light on your glass.

Paint your darkest colors first, any shadows, dark reflections in the glass, or a dark background. Then apply middle tones, and do the high-lights last.

You will notice how many different shapes and varieties of dark and light tones are reflected. This is especially true because a round reflective object can distort what it is reflecting. So if you are painting a lemon next to a silver plate, the reflection of that lemon might be elongated or shrunk into a stockier object.

When the shadows and lights are done, take your tiniest brush and add a lot of small, important details that bring the painting to life.

PAINTING CAN SAVE YOUR LIFE

*{240}*

# Exercise: Paint a Portrait of Another Person by Painting Their Shiny Objects

Ask your mother, your brother, your aunt, or a friend to take a picture of their vanity full of lipsticks and perfume bottles, or their watches and silverware. Use those objects to paint a still life that represents that person. The shiny objects of their life can result in a portrait of them.

The person who owns the shiny objects could also appear in your painting in some way, as a hand reaching for a perfume bottle or a reflection in a reflective surface.

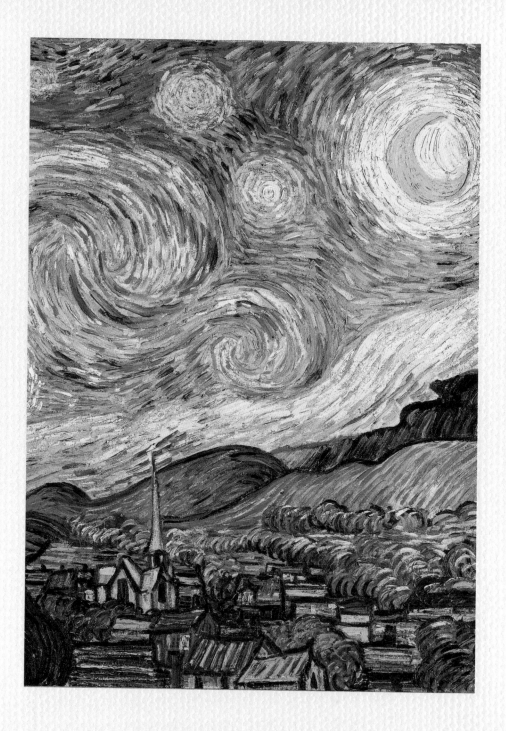

*chapter sixteen*

## WHAT MAKES A PAINTING GREAT?

"There are simply two kinds of music,
good music and the other kind."
—DUKE ELLINGTON

t was the end of our stay on Evia, an island off the coast of Greece. After a month of making art, eating moussaka, visiting countless Byzantine churches, and drinking too much wine, we were still not ready to leave.

On our final night, a few people were scheduled to do performance art pieces in the driveway of the estate. The pieces would be performed after dinner, when it was dark, because Andrea's performance was going to be lit by paper bag votives. I think she was doing something about menstrual blood. Or maybe that was Pam. Somebody did something related to menstrual blood, and it involved paper votives.

Eddie, the son of the owners of the estate where we lived, was going

to do a performance, too. Eddie never walked anywhere; he ran, and as a result was so underweight that he had to belt his pants tightly around his tiny waist to keep them up. His eyeglasses were massive and outdated, and the thick glass of the lenses magnified his eyes. I was only twenty-one when I knew him, so I don't know how old Eddie really was; he seemed middle-aged at the time.

Eddie served as a kind of do-it-all helper at the estate, refilling the wine jugs, running errands, and watering the wisteria. Sofia, the cook and housekeeper, did everything else, including killing and then braising rabbits and coming into our bedrooms each morning to light a fire in the woodstove at the foot of our beds—the morning air was brisk that high up in the mountains, even in April.

Today, Eddie might be diagnosed as high-functioning on the autism spectrum. Back then, I only understood him to be obsessed with major airline crashes.

"Human error, Sara, human error. Flight 752. Zurich to Cairo. 167 dead. Deadly crash. All 167 dead. Human error." He was also consumed with trivia about Dire Straits and REM, and he knew more about Mark Knopfler's personal biography than I know about literally any topic.

I was a little worried that I might laugh during Eddie's performance because I was a total jerk who couldn't imagine a scenario where Eddie would do something that wouldn't be silly. *We* would be the ones doing profound work, not Eddie. We were artists, after all, doing votive-lit performances and covering swimming pools in aluminum foil and building houses with sticks in the woods. Our work referred to modern art. It had satire! It had nods to architecture! IT HAD MENSTRUAL BLOOD REFERENCES, FOR GOD'S SAKE! Eddie was a sweetheart, but re-

ally, what did he know about art besides the lyrics to every Dire Straits song?

As soon as it was dark, the people slated to do performances set up their props, projections, and music. Eddie hurried down to the driveway the same way he hurried everywhere. He set a boom box on top of the picnic table and pulled out a flashlight.

Eddie asked for the lights to be turned off. He turned on the flashlight, put it under his chin, and lit his face from below. He seemed to glow with an almost mystical white light. Eddie hit play on his boombox, and out came the opening strains of REM's "Losing My Religion." Eddie, his big eyes closed, sang along with the song.

Eddie was so lost in the music that he pulled us into the song with him. His sincerity mixed with the basic, low-fi equipment resulted in something powerful. We were mesmerized.

Not only did I not laugh, I think most of us cried. Of course, nothing that night compared to Eddie's performance; his would be the only profound piece. Eddie proved that there is often nothing better than the combination of simplicity, heart, and cool lighting.

When I think about the individual elements of Eddie's piece, none of them point to its overall greatness. Was his voice great? I don't remember it being terrible, but I don't think he could win *American Idol* either. The sound coming from a portable stereo in 1993 couldn't have been of the highest quality, nor could music coming out of a much-loved, much-played audio tape on a tape deck. And his lighting system? It was a flashlight. If we make an analogy in painting terms, Eddie's piece was the equivalent of somebody making a painting with two sticks; no training; and some cheap, muddy colors.

What Makes a Painting Great?

So why do I remember that piece so vividly all these years later?

Why did Eddie's piece impact me so much?

What made it great?

For one thing, it was totally original. None of us would have conceived of it. And the simplicity of the single light, the boom box, and his voice is a reminder that sometimes the best art is the most basic. Things like an Ellsworth Kelly line drawing of a flower, a Picasso animal sculpture, a piano solo in a 1970s pop song, the rhythmic stomping of a Flamenco dancer, the stage manager's monologue in *Our Town*, or my favorite Frank O'Hara poem about kangaroos and jujubes.

There was nothing cool about his performance; Eddie put his heart into it. He thought about REM's lyrics day and night, so when he sang them to us, the words mattered deeply to him. For me, the passion of the artist making the painting, song, or film often translates into good work.

But art is subjective, and your criteria for greatness might be completely different than mine. You might have hated Eddie's piece and couldn't move beyond its lack of references to art and zero nods to menstruation. Once you have made enough paintings and looked at enough paintings, you will figure out which traits define greatness to you.

We must also consider how the term *great* came to be when applied to the Western canon. Much of what was deemed great enough to be canonized, and bought by museums, was work done by Western, white, male artists and deemed great by Western, white, male critics. But there is a new "great" being established that is more inclusive of many kinds of criteria from all different people, places, and experiences. We are being exposed to great artwork that has been around for many years but was never given the spotlight. The work of artists of color and female artists

and LGBTQ artists and people with non-MFA biographies and artists from places that are not America or Europe is getting reviewed in newspapers and art magazines. It is finally being shown at major museums. Artists working in materials that used to be minimized as craft, like textile and ceramics, are getting respect as well. And what is called "outsider art," great artwork that was once marginalized because of the biographies of the artists making it, more often gets the respect it deserves.

MANY PEOPLE IN MY LIFE HAVE RABID OPINIONS ABOUT WHAT CONSTITUTES "GREAT" ART. There's my friend Jordan, who wrote angry letters to the NYC public radio classical station after they had the audacity to add the theme from *Star Wars* to their rotation.

I once ran into my book-obsessed older brother at a rock concert in Minneapolis and tried to impress him with what I was reading.

"I'm reading *Light in August*," I told him, proud to be reading something as brainy as William Faulkner.

"Talk to me when you've read *Absalom, Absalom*," he said without missing a beat. To my brother, Faulkner's novel *Light in August* is good, but *Absalom, Absalom* is great.

I spent a lot of time with my friend Pete in my early twenties. His house was nothing more than guitars, amplifiers, computer gear, and milk crates full of albums. His collection ranged from surf guitar gods to Joni Mitchell to hard-core punk. Pete categorizes music into great or terrible and has no allegiance to any one genre. His passion for a musician's music is in direct relation to that musician's passion for making music.

Music being made by people like Betty LaVette and The Replacements and Junior Brown and Nina Simone and Neko Case and Nick Cave was extra great to him because of the heart the artists injected into their art. And if Pete didn't like whatever music was playing on the crappy car stereo of my Honda Civic, he ejected the tape from the tape deck and threw it out the car window while I was driving.

I sometimes feel like throwing paintings out of a moving car, too. I don't like navel-gazing art made by self-satisfied art world poseurs. I couldn't care less about work that is only interested in offending people. I have no interest in art that is all brain and no soul or anything that was phoned in for profit. I like brushstrokes, hatch marks, rough edits, and direct proof that what I am looking at is the work of a human being.

I like artwork that is made by people who care deeply and try hard.

But that's just me. Greatness is subjective, and it is up to you to define it for yourself.

THE THINGS WE'VE LEARNED SO FAR, LIKE VALUE AND COLOR AND STRONG COMPOSITIONS, ARE IMPORTANT, BUT THE EDDIE STORY ILLUSTRATES THAT YOUR AMBITION MUST GO BEYOND MASTERING THE VISUAL ELEMENTS IF YOU WANT TO MAKE GREAT ART.

Let's look at what some of those bigger goals might be, and in the process, we'll stockpile some questions that will help us know if, to kind of quote Prince, your groove is working or not.

## Is There a Mood?

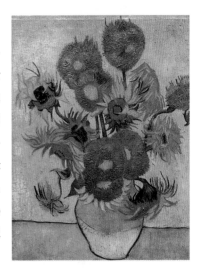

If you want your painting to capture your sadness over your separation from your family or your exuberance over a new romance, have you done enough with color to capture that mood?

Picasso painted mournful blue and blue-green paintings for three years, paintings that overwhelm the viewer with their moodiness. Goya painted his *Black Paintings* directly onto the walls of his home as he battled illness and depression.

But for van Gogh, every period was moody.

In this van Gogh painting of sunflowers, the palette is bleak, the petals of the sunflowers are blades, and the still life is a portrait of a battle with decay.

What if you try to paint your next flower painting like van Gogh? Mute your oranges, and exaggerate every petal into a blade. Did you mix enough dark greens and complicated nocturne colors for your shadows? Try painting with deep contrast and complementary colors to fuel your painting's mood.

If you want to capture the happy energy of a joyous, raucous dinner party, turn to the joyful paintings of Florine Stettheimer for inspiration. Squeeze out hot pinks, cadmium yellows, and brilliant blues, all colors appropriate for jewels, sparkles, and sunlight. Paint the sparkle of the birthday candle and the twinkle of the champagne bubbles. Exaggerate everything. Have birds of paradise flying around the ceiling, and paint words like *JOY! PARTY!* and *LOVE!* in the sky. Make up something that

wasn't there. Paint a feather boa around your friend's neck. I once did a painting of Rob in which I replaced the crown logo on the beer can he was holding with a heart. Painting is not photojournalism; you have no allegiance to the truth.

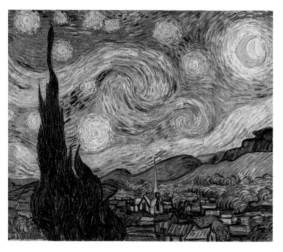

## Is There Energy?

So many things make van Gogh's *Starry Night* a great painting: the vibration of the yellow on the violet-blue, the depiction of the sleepy town beneath the wild night, the asymmetrical composition. But there is also the energetic brushwork, mimicking a sped-up Milky Way where planets and stars whizz around the sky.

Do your marks have such energy? If not, drink two double lattes and eat a candy bar. Get out blue and yellow paint, and tackle your canvas with as much vigor as you can. Don't worry about anything but the speed with which you fill the page.

Even a van Gogh still life, which by its very definition is a thing that is still, comes alive with the energy of his brush marks.

Go back to one of your earlier fruit still life paintings. Is there energy in your brush marks? If not, paint over it with more energetic strokes.

## Is It Beautiful?

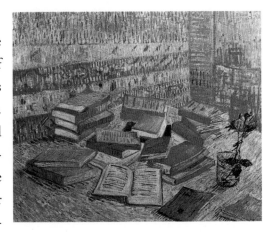

In the Catskills, we don't live far from the former house of George Inness Jr., a famous American landscape painter. He was on a trip to Scotland in 1894 with his father, another famous painter, George Inness Sr., when his father died suddenly of a heart attack at the age of sixty-nine. The younger Inness reported that they were watching a sunset when his father threw his arms in the air and proclaimed, "My God! Oh, how beautiful!" and then fell to the ground and died.

That is an appropriate way for a painter to die. We are wired to spot, create, and celebrate beauty.

But what is beautiful? There is that idea of symmetry, like the sunflower tattooed on my hip. Beautiful is an epic painting of a dramatic landscape. But Chaïm Soutine's paintings of cow carcasses, although certainly not clinging to conventional definitions of beauty, are beautiful to me, too.

What makes this van Gogh painting of a blossoming tree a study in beauty?

The composition is lovely, the tree tilts just slightly to the right, and the two branches on the left side are in harmony with the branches on the right. The warm, pink blossoms pop out from the cooler background. It captures something fragile and fleeting, like a vanitas still life; those blossoms will be gone soon.

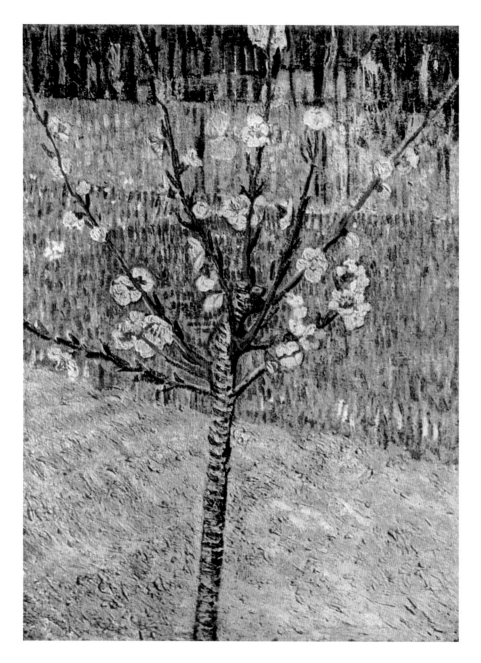

PAINTING CAN SAVE YOUR LIFE

*{252}*

## Is There Tension?

Some paintings are tense because the viewer is waiting for something to happen. Consider again Goya's *The Third of May 1808*, in which a group of men are moments away from being shot by a firing squad. We have stumbled upon a terrible tragedy and are waiting for the shots to ring out.

Other paintings are tense because of the interaction between two shapes, like those almost-touching fingers of Adam and God, or E.T. and Elliott.

## Does It Have Heart?

This is what Pete cares about in music and what I care about in everything. Did you care about your painting as you were making it? I don't know how to explain what heart looks like in an artwork; I just know that a person experiencing a work of art can feel its absence.

## HOW TO BE AN ARTIST

**M**any years ago, my friend Emily asked me to go with her to try out for the game show *Who Wants to Be a Millionaire*. I was broke and can never pass on a weird experience, so I happily agreed to go with her.

We took a written test, sat in the audience for two tapings of the show, and then some of us were asked to do one-on-one interviews with the producers. A few weeks later, I received a late-night phone call asking if I could be at the studio first thing in the morning to be a contestant, and ten hours later, I was in the ABC studios and Kelly Ripa's makeup woman was getting me camera-ready.

My odds for success didn't look good. The other contestants all had two or three weeks to prepare. Most had careers requiring high intelligence like librarians and engineers. It only took about five minutes of small talk for me to realize that I was the dumbest person in the room.

We waited out the morning in the tiny green room without phones

or reading material as, one by one, our fellow contestants were escorted to the stage for their segment by a producer wearing a headset. As we waited to be summoned, those of us who remained talked about our lives and watched the other contestants record their episodes on a TV bolted to the wall.

At lunchtime, we were led to the ABC commissary, where we were sequestered at tables in the back. After we ate our food, one older contestant began reading aloud from the CPR instructions poster on the wall.

"I'm sorry," he apologized. "It's my new habit. Ever since I got the call from the producer I've been reading every sign, looking at every plague, reading all the ingredients in my food. If I see an interesting leaf, I bring it home and research what kind it is. If I see a painting, I read about its history. I've memorized atlases and read encyclopedias. I'm going to be so sad when this is over. I've never been so engaged with the world."

What on earth was he planning to do after his taping? Just stop examining leaves?

*Too bad he wasn't an artist,* I thought at the time. *If he was, he would already have been examining the leaves.*

YOU HAVE LEARNED BASIC PAINTING SKILLS AND HOW TO GO BEYOND THOSE SKILLS TO CONSIDER THINGS LIKE MOOD AND TENSION. You have begun thinking about your criteria for a great painting. But are you an artist?

If you keep making paintings, you will become an artist at some point, but I have no idea where the boundary lies between a dabbler and

a painter, a hobby and a vocation. I do know that living as an artist goes far beyond making art. It is about making creativity and generosity, not consumption, the center of your life. Many of you might have been living as artists for years without labeling yourself one. You might be the person who overdelivers on every wrapped gift, who plants elaborate gardens, who attempts complicated international dishes and then invites twenty-five people to eat them with you. You already examine every leaf.

If you aren't feeling like an artist quite yet, there are things you can do to move toward a life centered on creating things and finding other people to create things with.

## Don't Wait for Inspiration

I became a magpie for inspiration growing up with a mother who was a librarian. This meant hours wandering the downtown Sioux Falls Public Library, reading century-old, regional true-crime stories on microfiche, and flipping through antique atlases in a back room.

As an adult, I accept all invitations, go to any museum, and attend live theater and outdoor concerts. I read all the things, watch all the stuff, and follow people on social media who are experts in narrow areas of study. I keep a folder on my laptop's desktop called "INSPO," where I drop images, passages from books, and news items that might fuel art at a later date. I have found painting inspiration at a space alien–themed restaurant, the rock section of the Natural History Museum, the La Brea Tar Pits, tapestries, dinner parties, bathroom graffiti, and liner notes.

Becoming more aware of your surroundings is the best gift of being an artist so you don't "sleepwalk through life." Remove your ear pods on

a subway, plane, or any public transportation. Take the bus instead of driving. Zadie Smith once said that if it weren't for the New York and London subway systems, her novels would be nothing but blank pages. Eavesdrop while in coffee shops and waiting in line at the post office. Take notes of what you hear, like this exchange I recently overheard between two older men at a charity bookstore:

> **Man 1:** He has a six pack, a twelve pack, and then goes to sleep.
>
> **Man 2:** To me, personally, that's a waste.

Many artists return to the same sources of inspiration over and over, while other painters are inspired by an endless array of ever-changing things.

The contemporary painter Julie Mehretu is inspired by comics, Chinese and Japanese calligraphy, planning grids, and architectural drawings of symbolic places like the New York Stock Exchange and the New Orleans Cotton Exchange. Joan Miró was inspired by the Fauves and Catalan folk art. Stanley Whitney is inspired by everything from Piet Mondrian to quilts.

There is only so far you can go as an artist without learning from and being inspired by old paintings and contemporary art, so go to galleries and museums. Spend hours in the art section of your library.

Go to places like history museums, aquariums, nature preserves, and planetarium shows with a kid or a grandparent so you can see it through their eyes.

Read thick novels written in other countries.

Examine all leaves.

## Work Hard

Rob will go to any exhausting extreme to perfect an artwork.

At one point during our first summer in the woods, right after a toilet was finally installed and the baby had been born, Rob switched from working day and night on the house to working day and night on sculptures for a show in London. He turned the unfinished portion of our house, which at that point was only a slab of concrete, wood frame, and plastic, into a studio.

I spent most of my day in the big room, nursing and changing the baby, reading, and writing when I could, as Rob filled the air with the smell of burning metal and sawdust. The baby became immune to the sounds of the table saw whizzing through a piece of wood followed by the scrap of wood hitting the concrete floor.

One night Rob came into the main room of the cabin, his protective eye goggles hanging from his neck, and considered the high ceilings.

"The studio ceiling isn't as high as the one in the London gallery space will be. Do you mind if I set up the sculpture here?"

"In the living room?" I asked, not a huge fan of the idea of him taking over the only space where I could be away from mosquitoes and sit on a piece of furniture.

"I'll just push the furniture into the kitchen," Rob said. Next thing you know, I was helping him move furniture and he was taking apart his massive sculpture and moving it piece by piece from the studio into the living room. After countless trips back and forth with the heavy sections of wood and metal, and many hours of rebuilding it, his wooden, elegant roller-coaster shape filled the room, and the once-cavernous space was

crowded with his art. The sculpture may have still been unfinished, but it was already beautiful, and the wood, which was old flooring from a high school basketball court and dotted with bits of red and yellow markings, flowed through the space, rising up to the ceiling and back down to the floor. And he did all of that dismantling and rebuilding with the knowledge that in a few days he had to take it all back down, pack it up, and ship it to London, where he would have to fly and unpack and rebuild that sculpture all over again. But he did all that extra work because that is what it would take to make a good piece.

In my early twenties, I visited my friend Allison in San Francisco. She pulled rolls of canvas out from under her bed to show me the large, hand-stitched, embroidered paintings she was making, modern tapestries with narratives depicting important moments of American history that resulted in socialist action, like the Triangle Shirtwaist Factory fire. Her nights were spent waitressing in four-inch heels at a retro cocktail lounge in the Mission, and she manned the vintage clothing store she owned during the day to support her art. When she wasn't earning money, she was sewing. On the edges of her tapestries she sewed hatch marks, one mark for every hour of sewing her work required. By the time a piece was finished, hundreds of hatch marks lined the edge.

My artist friends work harder than anybody I know because they are either hustling at a day job to pay for their art or they are hustling to keep their career alive so that their art remains valuable enough in the eyes of a very fickle art world. You don't get weekends or nights off as an artist.

## Welcome Criticism and Then Ignore the Mean Critics

For a few years in college, I lived next door to a local eccentric who, legend had it, had been a young mathematical genius who took too much acid in the 1960s and never recovered.

I had multiple college friends who lived with me in that apartment building in different apartments, spread out across multiple floors. At first this eccentric didn't have much to do with us, even though only about ten feet separated our two buildings. But one night we invited some friends over for a party on our roof, and the eccentric neighbor

climbed out of his window and onto the sloped roof of his building where he began hurling empty cans of beer and soda at us. They were too light to make it to our roof, and we started giggling. Our laughter enraged him so much that he went inside and then returned to his roof to throw full cans of beer and soda at us as we ran for cover.

A few nights after that, we were watching TV in my friend Marie's apartment when we looked over to see the neighbor glaring at us from his kitchen. He began mouthing what I can only imagine to be a series of expletives. He opened his window to yell at us some more. Our shocked laughter made him even angrier, so he took his spoon, filled it with spaghetti in red sauce, and threw spoonfuls of food at us. That made us laugh even harder, so he threw the actual spoon at us, then the jar of spaghetti sauce, and eventually the entire pan. Frustrated by his inability to hit our building, he slammed the window and retreated into his apartment.

That neighbor is who I think of when I think of mean, not helpful, critics. You will only get better as an artist with the help of constructive criticism, but some critics are just being petty, jealous, or cruel. That neighbor is the friend, child, or spouse making unhelpful comments about your painting or snide comments about your desire to become an artist. He's the one throwing spaghetti at your plans to have a more creative life. As Stephen King pointed out in his amazing book *On Writing*, eventually somebody will come along and try to make you feel lousy about making art.

But it is just as likely that you might be throwing spaghetti in the form of endless self-criticism and the expectation of instant perfection.

You might be telling yourself that you don't deserve two hours on the weekend to paint or thirty dollars' worth of art supplies.

After you have painted from this book for a while, I suggest finding a class where your work can be critiqued, constructively, by a painting teacher and other painters. If there isn't a class nearby you can join, start a critique circle with friends who are also making art. Be supportive; tell each other what you love; and find kind, thoughtful ways of saying what you think could be improved.

And as far as those people in your life offering their unhelpful opinions, the only thing to do is to ignore the beer cans. Ignore the spoon. Ignore the pot of spaghetti.

## Be Generous

Artists are often a lot of fun to hang out with. They might show up at your party with a massive piñata or bags of sparklers. Sometimes they wear amazing clothes. They give thoughtful gifts wrapped in homemade wrapping paper. You might open your mailbox and find a homemade postcard from your artist friend who lives in a faraway place. My friend Yuri once flew over a Ramones cover band from Japan for her art opening and then ran around the crowd throwing red roses at people as the band played "Rock 'N' Roll High School."

I don't know why everybody doesn't want to have more artists in their life.

But there is an entrance fee to hang out with artists, and that entrance fee is living with generosity as your driving force. Most artists don't want

to hang out with people who are stingy. And I'm not talking about money; I'm talking about a stingy spirit.

The reason that artists can build massive installations like the homemade boat that the artist Swoon sailed into the Venice Biennale is because of all the labor provided to her by generous artists. Artists who want to refurbish old houses or build cool, new spaces rely on their generous friends for help. Some years ago, I hung out with a lot of people who were getting their MFA in film at NYU. For three years, those aspiring filmmakers were in a constant rotation of spending long days working on one another's thesis films, often for weeks at a time, for free.

I don't understand not expanding the guest list for a birthday party. I think driving five hours to see a friend's photography show or helping somebody move a sculpture during a snowstorm or loaning a friend money when they need it, no matter why they need it, is totally normal because my circle of close friends all do those things.

It raises a tiny red flag in me when somebody calls out any of that behavior as being unusual because it signals to me that they don't do it themselves.

Being generous with time, talent, and money is just what you do when you are an artist because being an artist is so hard. Nobody can do it without help from their friends.

## Master Your Craft

Learn everything you can about painting, and never stop learning.

## Insert Joy, Fun, and Beauty in Your Life

In our early twenties, my friends Chris and Woody lived in an old warehouse in downtown St. Paul, Minnesota. It was full of things that they built to make their living space more beautiful or more fun. They even screwed an old booth from a diner onto a platform and put it on wheels so you could ride on it while drinking beer during their parties. At a different house, Woody set up a BB gun shooting range in his basement.

Twenty years later, they both still live this way. At his magical house in upstate New York, Chris and his equally fun and beauty-obsessed wife, Tracy, have turned their old farmhouse into a Bohemian world full of musical instruments, elaborate cocktails, and walls covered in the artwork of their friends. They have a menagerie of animals wandering around, and at any point a random chicken, pygmy goat, or giant dog might wander into the house. At night, after a massive meal of homemade pasta and roast chicken, you might find yourself in the middle of an impromptu dance party; they keep a disco ball over their dining room table just in case.

My brother-in-law Pete cut a hole into his wall just so his kids could crawl between their bedrooms and their playroom without having to go the long way around. He put a tiny fairy house into a neighbor's tree that he filled with gifts and notes for his daughters and the other kids in the neighborhood to discover.

Our friends and Minnesota neighbors have turned their old dining room into the kind of game room you might find in an old lodge, full of games, a foosball table, and an old stereo.

Bruce and Bud live deep in the Smoky Hills, not far from our Minnesota cabin. Every Monday night in the summer they host a bread and

soup party. Using the giant pizza oven that they built themselves, they bake an array of delicious sourdoughs, focaccias, and French loaves. We drink their homemade liquor. Everybody is invited.

My friends Sophie and Reina are both filmmakers. Twenty years ago the three of us formed a make-believe sorority. It was a pretty unimpressive sorority because we were the only three members and we only had one activity: if one of us was struggling emotionally or we felt like celebrating, about every six months, we met to eat lobster and share a bottle of champagne. It wasn't about the luxury of the lobster and champagne; it was about toasting one another and being fancy.

Being an artist isn't so much about rejecting wealth as it is committing to having an inclusive, open-hearted life focused on joy, community, and beauty instead of buying stuff for the sake of having stuff, an alternative life that either appeals to you or it doesn't.

Luckily, this joyful, generous, inclusive life does not require a lot of money. You can decorate your kitchen using paper flowers made with ten dollars' worth of tissue paper. Make a giant pot of cacio e pepe and host a dinner party. Buy a plastic cotton candy machine from Walmart and invite some kids over. Plant some flower seeds. Bake a cake for no reason and then spend hours decorating it.

## Be More Curious

When Rob and I are older and our kids leave home, our marriage will be saved by a few shared things: a love of art, the desire to stop at every random museum celebrating rattlesnakes and regional histories, wanting to eat at diners and off-the-beaten-path restaurants, and the compulsion to talk to every person we meet.

My group of artist friends are equally curious people also guilty of pestering innocent strangers, driving out of their way for a famous beignet, eating at a Hell's Kitchen restaurant just because it is owned by a former Elvis impersonator, and paying too much money for five minutes on a bumper boat just because summers only come around once a year.

If those friends and I ever decide to do a cross-country road trip together, it would take approximately three years for us to travel from New York to L.A. We couldn't go ten miles without somebody demanding to pull over to photograph a plant, walk through a wildlife refuge, talk to a

farm stand owner about squash varieties, eat at a gas station famous for its Frito Pies, or pull over to a roadside bar in the middle of nowhere for a beer.

We might not make art about all of those moments, but without a doubt, every pit stop we make out of curiosity fuels our art.

## Be Courageous

At one summer potluck a few years ago, pork sandwiches were surrounded by a circle of Pyrex dishes holding potluck staples like seven-layer dip, deviled eggs, broccoli-grape-mayonnaise salad, slices of blood-red watermelon, and a chocolate cake.

As the sun went down, the mosquitoes came out, and I joined a circle of people standing around a fire who were listening to our friend Cheryl tell a story. Cheryl has long dark hair and kind eyes. A midwife and a veteran, she is physically affectionate, often moving somebody's hair behind an ear or scratching their back as she talks with them.

With the bonfire lighting up her classical features, Cheryl told a story about a drumming circle during a drought a few years earlier.

"We were all drumming, trying to call in the rain. We were drumming and drumming and then all of the sudden this fierce, black rain cloud started moving across the sky. It came out of nowhere." Cheryl's hands moved through the air. "The cloud traveled right over us. We kept pounding and pounding and then the rain started to fall on us. It was amazing."

Cheryl lowered her hands and shrugged.

"But then we all got scared of our own power. As soon as we were scared of being so powerful, the rain cloud disappeared."

"Fear kills magic," Cheryl said, shaking her head.

Be brave about trying this new way of living and your desire to make art because bravery is what will save the magic. You can't be scared of being judged or criticized if you decide to forgo some of the things you used to do in favor of new creative interests or passions. Living an unconventional life that is not just focused on materialism and consumption is sometimes mocked. Some people try to convince everybody that making art or celebrating art reflects some desire to be superior or elite in an era when *elite* is America's dirtiest word. But big things are at stake if you don't find the courage to lead a more creative life. You might look up from your phone and find that a decade has passed without any true engagement with your life.

PAINTING CAN SAVE YOUR LIFE

## Become an Optimist

"To be an artist is to believe in life."

—HENRY MOORE

Optimism might be the biggest requirement for becoming an artist. Personally, I am optimistic that we are in a transitional stage as human beings and that art will play some small part in moving us toward being better human beings and making the world a better, more equitable, more enlightened place.

You need to find your own reason to be optimistic. Maybe you believe that art will play a role in saving the planet or stopping fascism. Maybe you believe that making something beautiful for another person will make their life a little better.

There are days when I am less convinced that art has the power to do anything at all, much less save anyone. But those doubts aren't tenacious or hearty; they are a bubble in a vanitas painting, disappearing as quickly as they came. I return to the idea that with all of the madness and sorrow and violence and an earth on fire, if the artists and scientists don't believe that things can get better, and if we don't build the feedback loop of generosity, ingenuity, and beauty necessary to create all the solutions, then we're all doomed.

I believe that art can save our lives, and I won't be convinced otherwise.

# acknowledgments

Thanks to Penny and Jim Woster, lovers of music and books, for passing that love of books and music on to us. My mom always had her stereo on and spent too much time driving me from piano lessons to the bookmobile. My dad never passed up the chance to try a new thing, going from cattleman to TV star to real estate agent to restaurateur to founder of a farm-to-table museum. To paraphrase John Stewart talking about Bruce Springsteen, my dad empties his tank every day. More interested in community, family, and the arts than money and stuff, they make it look easy to live meaningful lives.

Thanks to Rob for building me two amazing spaces to live, celebrate, write, and paint in, for always being up for a drive out to Coney Island, and for helping me take care of our two best creations and my favorite people on the planet, August and West. And while I know you guys hate museums now, I cling to the fantasy that someday you will actually *want* to go to the Whitney with me.

To my editor and friend Sara Carder, thank you for taking a chance on this new type of how-to-paint book. Your deep knowledge of art,

editorial wisdom, and thoughtful guidance resulted in a much better book than the one I first handed you. And to your team at TarcherPerigee, including Ashley Alliano, Rachel Ayotte, and Christy Wagner, thank you for your patience and energetic support of the book. To Lorie Pagnozzi, Linet Huaman, and the entire creative team at TarcherPerigee and Penguin Random House, thank you for conjuring up such a beautiful book.

To my agent and friend Nicki Richesin, who was the first person who ever asked me to write anything for public consumption many years ago, and who saw a place in the world for this book, thank you. When your agent is the smartest, most charming, and most determined person in publishing, you are a lucky writer. To Wendy Sherman and Callie Deitrick for helping sell this book and to the team at Dunow, Carlson & Lerner for helping me imagine the future.

To Michelle and Pete for giving birth to three of my favorite people on the planet, Tessa, Lulu, and Simon, and for showing me how to make family life more fun. And to Jimmy for being the true artist in our family who showed me what commitment to craft actually looks like.

To both Grandma Maries for letting me start out life with the false assumption that I was perfect. Thanks to the crazier Marie for teaching me that being an eccentric who makes art is a viable life option.

A very special thanks to my Jorgenson and Woster aunts and uncles because growing up surrounded by so many good people is a gift. To my cousins, you are all awesome and I'm glad we grew up with parents who really only like hanging out with their siblings. And thanks to the Fischer family for graciously accepting me into their family.

To the generous friends and family who read this and other writing

over the years, or helped me in my pursuit of getting published, especially Jimmy, Anna Mitchael, Sophie Goodhart, Mary Alice Haug, Lara Widman, Jennifer Widman, Ales Ree, Lisa Sardinas, Laura Geringer Bass, Rony Vardi, Amy Thielen, Renee Dale, Nils Shelton-Johnson, Lisa M. Collins, and Mark Lamster. So many thanks.

To the friends who have supported or shown my artwork over the years, including Missy Wilson, Kanae Maeda, Ivy Brown, Kyla Ryman, Brian Wiggins, Carmen Ferreria, Mark Weiler, Tessa Beck, Hetty McKinnon, and the art-obsessed Gisela Gueriros.

The very first students who took a chance on The Painting School blew me away with their talent. Thank you, Suzi Jones, Lynn Husum, Julia Gordon, Ali Dib, Gabby Casella-Nicosia, Jocelyn Kaye, Jeanne Sullivan Meissner, and Bridget Roddy. And many thanks to those who followed.

To my writer friends I have made over the years at the Jane Street Writer's Workshop, especially its brilliant leader, Alexandra Shelly, I am forever grateful for your feedback, friendship, and good times. Whether sitting in Alexandra's living room with a view, or writing on the sundeck at the retreat run by radical nuns, Jane Street was my MFA equivalent and you are the people I strive to impress.

And a special thanks to David Bumke, Tracy Marx, Harriet Goldman, Martin Biro, Lisa Sklar, and Lynda Curnyn of the Tri-State Tough Writer's Group, who helped me develop much of this book over Zoom and kept me inspired and entertained with their writing during the pandemic.

I wish I could list every one of my friends that I am lucky to have, including the lifelong ones from Sioux Falls, the extended friends/family

group born out of late nights at MCAD and the dorms of U of M, the crew from Greece, the friends who stayed late with me at First Avenue and the artists from the S&M building, coworkers turned friends from jobs in malls, art colleges, construction company basements, Powell and Fallon, neighbors from the Williamsburg days, the people who inspire me in the art world, and friends and neighbors in Two Inlets and Cragsmoor. A special thanks to the men and women in Brooklyn who helped me figure out this parenting situation and have repeatedly saved my sanity with coffee, dog walks, and wine. A special thanks to Rachael Powell for keeping me employed for so many years and always taking my phone calls from hospitals.

Thank you to the bright minds of the New School and the University of Minnesota, including Suzanne Snider, Ernie Whiteman, Clarence Morgan, Diane Katsifica, and especially Hank Rowan for introducing me to Joseph Campbell.

To the many artists and art teachers who I read, watched, and learned from in order to build this painting program, I am so grateful for you all passing on your knowledge of painting and art and hope that in return I can contribute something to this generosity loop that is teaching art. From library books to YouTube channels, I sucked up all the information you put out there. I am especially indebted to Arts21, all PBS and BBC Documentaries, Lynda Barry, and Betty Edwards.

Thanks to the Department of Education in Sioux Falls, South Dakota for always funding the arts in the public schools. At Robert Frost Elementary, Patrick Henry Junior High, and Lincoln High School, a series of amazing teachers and teaching artists taught us the saxophone, conducted us in a choir, directed us in plays, read us poetry, forced us to

read Homer, and taught us to paint. Nobody will ever convince me that the city's continued financial success and constant presence on best places to live lists is not directly linked to the ongoing commitment to investing money in helping kids make art and music.

Fund arts education. Grow more artists. Art makes communities better.

# resources

## Safe Use and Responsible Disposal of Art Supplies

The number of years that I just poured my paint water down the drain and walked around with paint caked onto my fingers and fingernails as I blissfully ate sandwiches in my studio is mortifying for me to consider. I got older and wiser and now I wish that I had known about the adverse effects of my bad habits earlier.

But it is not too late for you to get in the habit of not letting paint get on your hands, being a responsible steward of your materials by disposing of them in the correct way, and just being conscious of your artistic practice's impact on the planet and your health.

Since I am not an expert on this extremely important aspect of painting, I will point you in the direction of the organizations and people that can provide you the information you need to paint in a safe way that does as little harm as possible to the environment or you.

**U.S. Consumer Product Safety Commission**—They put out art and craft safety guides that list the hazards associated with art and crafts materials. If you want to see the strictest guidelines about toxins and ingredients, check out the laws of California and the EU.

**The Health and Safety pages on the websites of your paint manufacturer**—All paint brands have information on their websites of the safety of their materials and how to safely dispose of them; those sections cover everything from best practices to how to clean your brushes so that less paint goes into the water. My personal favorite brand, Golden Acrylics, sells a kit, the Golden Crash Paint Solids Waste Water Cleaning System, which separates acrylic and watercolor solids from water and prevents them from going down the drain.

**Your state Department of Environmental Conservation**—This is the place to go for properly disposing of leftover paints, and it tells you who to contact with questions.

## Books That Will Make You a Better Painter

Albers, Josef. *Interaction of Color: 50th Anniversary Edition*. Yale University Press, 2013.

Aristides, Juliette. *Beginning Drawing Atelier: An Instructional Sketchbook*. Monacelli Studio, 2019.

Edwards, Betty. *Color: A Course in Mastering the Art of Mixing Colors*. TarcherPerigee, 2004.

Edwards, Betty. *Drawing on the Right Side of the Brain:* The Definitive, 4th Edition. TarcherPerigee, 2012.

Kloosterboer, Lorena. *Painting in Acrylics: The Indispensable Guide*. Firefly Books, 2014.

Livingstone, Margaret S. *Vision and Art: The Biology of Seeing*. Abrams, 2008.

Parramón Editorial Team. *The Practical Handbook of Color for Artists*. Paperback. B.E.S. 2013.

St. Clair, Kassia. *The Secret Lives of Color*. Penguin Books; Later Printing edition, 2017.

## Books That Fuel My Creative Process

Barry, Lynda. *What It Is*. Drawn and Quarterly, 2008.

Cameron, Julia. *The Artist's Way : A Spiritual Path to Higher Creativity*. TarcherPerigee, 2002 (first published 1992).

Csikszentmihalyi, Mihaly. *Flow: The Psychology of Optimal Experience*. Harper Perennial Modern Classics, 2008.

Erdrich, Louise. *Books and Islands in Ojibwe Country: Traveling Through the Land of My Ancestors*. Harper Perennial, 2014.

King, Stephen. *On Writing: Some Instructions on Writing and Life*. Generic, 2012.

Lamott, Annie. *Bird by Bird: Some Instructions on Writing and Life*. Anchor, September 1, 1995.

Lynch, David. *Catching the Big Fish: Meditation, Consciousness, and Creativity*. TarcherPerigee, 2007.

Questlove. *Creative Quest*. Ecco, 2018.

Ringgold, Faith. *We Flew Over the Bridge: The Memoirs of Faith Ringgold*. Duke University Press, 2005.

Rodgers, Nile. *Le Freak: An Upside Down Story of Family, Disco, and Destiny*. Sphere, 2011.

Salz, Jerry. *How to Be an Artist*. Riverhead Books, 2020.

Tan, Amy. *Where the Past Begins: A Writer's Memoir.* Ecco, 2017.

Tharp, Twyla, and Mark Reiter. *The Creative Habit: Learn It and Use It for Life.* Simon & Schuster 2006.

Tweedy, Jeff. *How to Write One Song: Loving the Things We Create and How They Love Us Back.* Dutton, 2020.

Urist Green, Sarah. *You Are an Artist: Assignments to Spark Creation.* Penguin Books; 2020.

Wellington, Hubert. *Journal of Delacroix (Arts & Letters).* Phaidon, 1995.

Wojnarowicz, David. *Close to the Knives: A Memoir of Disintegration.* Vintage, 1991.

## Online Content That Inspires

**Art 21**—I watch the content on the Art 21 website like some people watch vintage moments in sports. You hear from the artists themselves about their work and their influences. You see them in the studio or out in the world. It is the best way to hear from a wide range of contemporary artists about their creative process and inspirations.

**BBC and PBS Content on YouTube**—It is a given that there are some issues with platforms like YouTube, all that content, all those conspiracy theories. But the ability to watch some of the best programming ever made about art and history for free day and night is one of the best reasons for the platform to exist. Spend some time with great shows like *Modern Masters* and *The History of Art in Three Colours.*

**Getty Museum Recording Artists**—This podcast is a deep dive into the lives and work of leading artists as told by their own voices based on interviews from the 1960s and, '70s.

**The Social Media Channels of the World's Great Museums**—Following wonderful institutions like the Whitney Museum of American Art, the Uffizi Gallery,the Louvre, the MOMA, Towada Art Center, Victoria and Albert Museum, LAMOCA, the Studio Museum in Harlem, Brooklyn Museum, Louisiana Museum of Art, the Prado, the Tate, and more! These amazing channels allow you access to talks and panels with famous artists and curators, behind-the-scenes tours of new shows, and insights from the curators and artists about what drives an artist or a movement.

# index

Note: Page numbers in *italics* refer to illustrations.

Author photo © Maria Midões

# about the author

**SARA WOSTER** is a painter, teacher, and founder of The Painting School
in Brooklyn, New York. Woster shows her work in the United States and
internationally, in solo shows and group exhibits. She has illustrated several
children's books, and her animations, multimedia, and collaborative
performances have been shown at numerous art venues including the Hammer
Museum, UCLA, and Franklin Art Works in Minneapolis. She has been granted
a Jerome Foundation Emerging Artist Fellowship, a Franconia Sculpture Park
residency, and a Brooklyn Arts Council SU-CASA residency. Woster and her
husband, Rob Fischer, established artist residencies in northern Minnesota and
the Bleakley House in New York.

# art credits

Page 36: *Young Lady in 1866*, Édouard Manet, The Metropolitan Museum of Art, New York; Page 42 and page 44: The Color Wheel Company, https://colorwheelco.com; Page 45: Vincent Van Gogh, *Terrace of a café at night (Place du Forum)*, Kröller-Müller Museum; Page 52: *The Eclipse,* Alma Thomas (Photo Credit: Smithsonian American Art Museum, Washington, DC / Art Resource, NY); Page 59: Penny Woster; Page 63: *"Roman stripes" variation*, Deborah Pettway Young © 2021 Estate of Deborah Pettway Young / Artists Rights Society (ARS), New York, Fine Arts Museums of San Francisco, San Francisco, CA, U.S.A. (Photo credit: Pitkin Studio / Art Resource, NY); Page 67: *The Toilers of the Sea*, Albert Pinkham Ryder, The Metropolitan Museum of Art, New York, George A. Hearn Fund, 1915; Page 68: *Wearing Blanket*, Navajo, The Metropolitan Museum of Art, New York, The Michael C. Rockefeller Memorial Collection, bequest of Nelson A. Rockefeller, 1979; Page 87: *Swift Dog Strikes an Enemy*, Swift Dog, The Metropolitan Museum of Art, New York, The Charles and Valerie Diker Collection of Native American Art, Gift of Charles and Valerie Diker, 2019; Page 93: Tessa Quale; Page 101: *The 3rd of May 1808: Execution of the Defenders of Madrid*, Francisco Goya Museo Nacional del Prado; Page 102: *The 2nd of May 1808 in Madrid or "The Fight against the Mamelukes,"* Francisco Goya, Nacional Museo del Prado; Page 119: *Still Life with a Ginger Jar and Eggplants*, 1893–94, Paul Cézanne, Bequest of Stephen C. Clark, 1960, The Metropolitan Museum of Art, New York; Page 120: *Still Life with Apples and a Pot of Primroses*, ca. 1890, Paul Cézanne, Bequest of Sam A. Lewisohn, 1951, The Metropolitan Museum of Art, New York; Page 122: Melissa Grillo Aruz; Page 133: Julia Gordon; Page 144: Emma Neath; Page 149: Jocelyn Kaye; Page 154: *The Luncheon on the Grass*, Édouard Manet, 1863, © Musée d'Orsay Credit Line: © RMN (Musée d'Orsay) / Hervé Lewandowski; Page 173: Suzi Jones; Page 179: Photo by Rob Fischer; Page 203: *The Scream*, Edvard Munch (Photo credit: Borre Hostland / The National Museum); Page 207: *Les arbres (The Trees)*, André Derain © 2021 Artists Rights Society (ARS), New York / ADAGP, Paris, (Photo credit: Albright-Knox Art Gallery / Art Resource, NY); Page 209: Archive Collections, Finnish National Gallery / Arkistokokoelmat, Kansalliskalleria; Page 210: Gisela Gueiros; Page 220: *Family Lunch*, 1899, Édouard Vuillard, © RMN-Grand Palais / Art Resource, NY © 2021 Artists Rights Society (ARS), New York; Page 222: *Christmas Morning, Breakfast*, 1945, Horace Pippin, Cincinnati Art Museum, Ohio, USA © Cincinnati Art Museum / The Edwin and Virginia Irwin Memorial/Bridgeman Images; Page 234: *Vanitas Still Life*, 1603, Jacques de Gheyn II, Charles B. Curtis, Marquand, Victor Wilbour Memorial, and The Alfred N. Punnett Endowment Funds, 1974; Page 242 and page 250: *Starry Night*, Vincent van Gogh, Museum of Modern Art, Acquired through the Lillie P. Bliss Bequest (by exchange); Page 249: *Sunflowers*, Vincent van Gogh, Van Gogh Museum, Amsterdam (Vincent van Gogh Foundation); Page 251: *Still Life with French Novels and Rose*, Vincent Van Gogh—Private Collection; Page 252: *Peach Tree in Blossom*, Vincent van Gogh, Van Gogh Museum, Amsterdam (Vincent van Gogh Foundation); Page 260: Rob Fischer